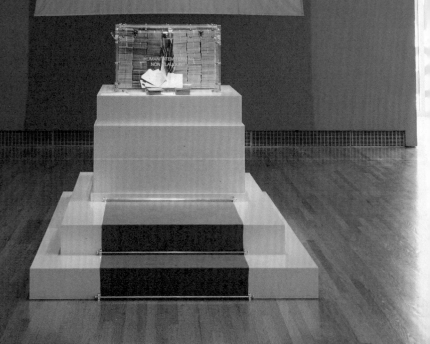

DIGNITY HAS NO NATIONALITY

DEEP
VELLUM

Deep Vellum Publishing
3000 Commerce St., Dallas, Texas 75226
Deepvellum.org · @deepvellum

Deep Vellum is a 501c3 nonprofit literary arts organization
founded in 2013 with the mission to bring the world into
conversation through literature.

First edition, 2022

Support for this publication has been provided in part by
a grant from the National Endowment for the Arts and by
Ignite Arts Dallas at SMU, Meadows School of the Arts.

Library of Congress Control Number: 2022932165

ISBN paperback: 978-1-64605-170-0
ISBN eBook: 978-1-64605-171-7

Cover design, interior design, and
typesetting by Cristina Paoli · PERIFERIA

PRINTED IN THE UNITED STATES OF AMERICA

TANIA BRUGUERA:
THE FRANCIS EFFECT

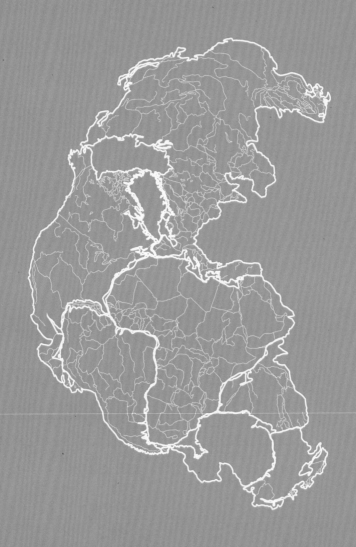

Edited by Noah Simblist

TABLE OF CONTENTS

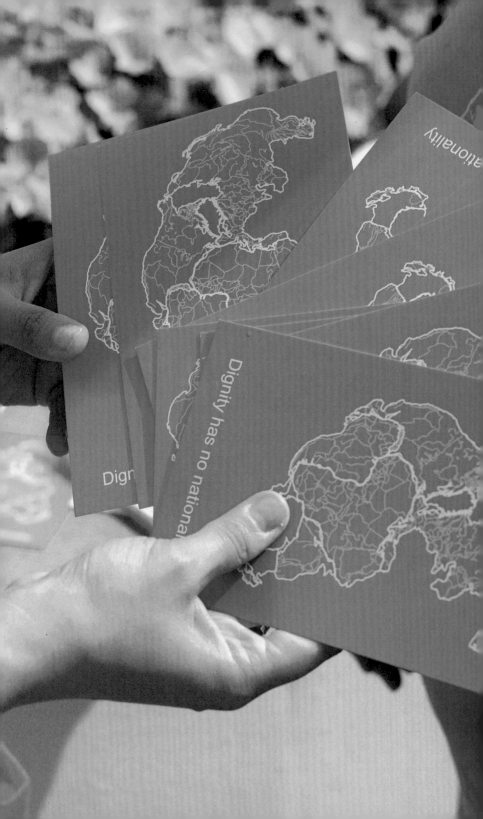

PREFACE
Noah Simblist

This book stems from *The Francis Effect* by Tania Bruguera, which took place at the Solomon R. Guggenheim Museum in New York from June 21 to October 1, 2014, as part of the Guggenheim UBS MAP Global Art Initiative exhibition *Under the Same Sun: Art from Latin America Today*. Produced in collaboration with the Santa Monica Museum of Art (now the Institute of Contemporary Art, Los Angeles) as part of their exhibition *Citizen Culture: Artists and Architects Shape Policy* (September 13 to December 13, 2014), *The Francis Effect* is the culminating project of The 2013 Meadows Prize, awarded to Bruguera by Southern Methodist University's Meadows School of the Arts.

The Francis Effect began in 2014 as a performance, and the book was meant to come out not long afterward. But Bruguera's intensive exhibition schedule, combined with her political challenges in Cuba, delayed publication. In 2015, not long after President Obama opened up diplomatic relations with Cuba, Bruguera tried to stage a performance as a part of her project #YoTambienExijo, which led to her arrest, detention, and interrogation for some time. In 2017, she worked with Lucía Sanromán on a retrospective of her work at the Yerba Buena Center for the Arts in San Francisco, which included an exhibition presentation of *The Francis Effect* and later traveled in 2018 to MUAC in Mexico City. Her installation *Untitled (Havanna, 2000)* was staged at the Museum of Modern Art in New York in 2018, and in 2019 Bruguera staged a major installation at the Tate Modern in

London that was tied to a local community project. As we are making the final adjustments to this book in late 2021, she has once again faced arrest, detention, and interrogation by Cuban authorities.

As the curator's conversation will elucidate, this project centers on Bruguera's instinct for collaboration and her desire to maximize both the artistic and political impact of her project by bringing us together. But since the beginning of this project in 2014, many of the principal collaborators have made professional moves. Christina Yang, who was at the Guggenheim Museum in New York, is now at The Berkeley Art Museum and Pacific Film Archive. Lucía Sanromán, who was a guest curator for the Los Angeles iteration, is now the director of the Laboratorio de Arte Alameda in Mexico City. I moved from SMU in Dallas to VCU in Richmond.

I want to thank my colleagues and collaborators, Christina Yang and Lucía Sanromán, for their dedication to this project and also Pablo León de la Barra, who was the curator of the Guggenheim exhibition *Under the Same Sun: Art from Latin America Today*, which launched *The Francis Effect*. I am very thankful for the patience of the contributors, Our Literal Speed, Saskia Sassen, and Nicholas Terpstra, as this book project unfolded over the last few years. I also am very thankful to Clyde Valentin, director of Ignite Arts Dallas at SMU, which has supported this publication despite its many twists and turns since beginning as a part of Bruguera's Meadows Prize. I also am grateful to Will Evans, Serena Reiser, Sara Balabanlilar, and Walker Rutter-Bowman at Deep Vellum Publishing for taking on this project and ushering it into the light of day. Thanks also to Cristina Paoli for a wonderful design. Most importantly, I am eternally grateful to Tania Bruguera for her fierce insistence on justice and her belief that cultural work and activism for political and social transformation can work hand in hand.

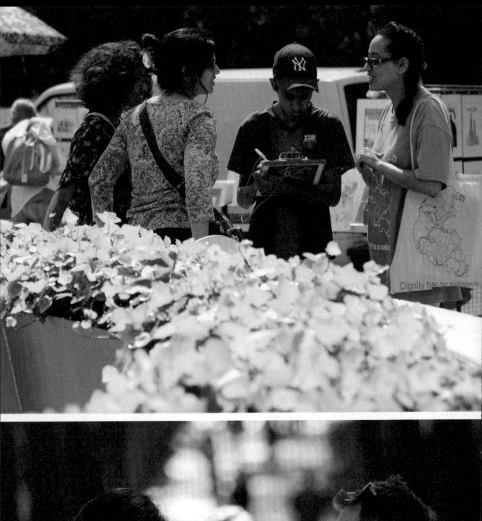
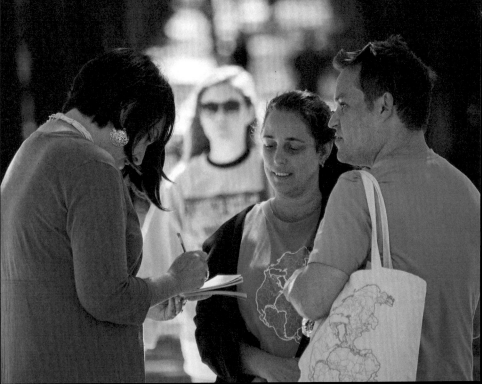

INTRODUCTION
Noah Simblist

The Francis Effect is a performance in the guise of a political cam-
paign, the aim of which is to request that the pope grant Vatican City
citizenship to all immigrants and refugees as a concrete gesture of
support that transcends simple charity and instead offers legal pro-
tection. Tania Bruguera refers to Vatican City as having been "born as
a conceptual nation without borders," arguing that its international
population aligns it with the idea of a global state into which people
are accepted without judgment. An example of this sentiment in *The
Francis Effect* is the use of Pangaea as its icon. The artist and her
collaborators gathered signatures on postcards, addressed to Pope
Francis, in Cuba, France, Germany, Israel, and Italy, as well as in
Dallas, Los Angeles, and New York. As of October 2014, over fourteen
thousand signatures were gathered from participants living in 190
countries. By using the form of the petition, the project appropriates
a fundamental forum for civic engagement and addresses the denial
of political rights to immigrants and refugees. The broad goal of the
project is to challenge public perceptions of immigration by respond-
ing to recent shifts in world culture.

While bringing together the subjects of religion and migration
through the pope and Vatican City, both of which are often regarded
as apolitical, the artist reminds us of the Catholic Church's long his-
tory of helping to establish kings and queens, treaties and borders,
and of its influence over world affairs. The pope's status as a head of
state empowered to enact local governmental policy to international

effect offers participants in the project a plausible role in using art as a vehicle for social change. Throughout the project, Bruguera has maintained a unique relationship with her audience, engaging in direct conversations on the streets outside museums with individuals who often take her and her collaborators to be canvassers. She thereby blurs the line between art and life and underscores her work's political element.

The style of this book is conversational, collaborative, and self-reflexive—much like Bruguera's practice. It deliberately is interdisciplinary, drawing from curatorial practice, art history, sociology, and religious studies. It's also global, weaving narratives that incorporate, by implication, the Americas (including the US, Latin America, and the Caribbean), the Middle East and North Africa, Europe, and elsewhere.

One important idea in Brugeura's practice has been what she calls "politically timing-specific" artworks. In 2014, when *The Francis Effect* began, the migration of Syrian, Afghan, and Iraqi refugees leaving their war-torn homes for Europe via the Mediterranean was reaching a crisis point. For many of them, Italy and Greece became the first point of entry to the continent, and media images showing thousands of desperate people washing up on the shores of Southern Europe shocked the world. The other main immigration crisis surrounded young children fleeing violence in Central America who moved north toward the United States, as Saskia Sassen notes in her contribution to this volume. Given these crises, *The Francis Effect* could be seen as a "politically timing-specific" work in response to those moments.

But when the book about this project comes out so long after the initial performances in 2014, one might question its relevance at the time of publication and for future readers. Sadly, while the immigration patterns of 2014 have changed, immigration has continued to be an unresolved issue around the globe. Furthermore, it was a central issue in the election of Donald Trump in 2016 and his subsequent administration, which demonized Latin American, Muslim, and Asian immigrants and made a border wall central to his legacy. The hope is that this book can be useful not only for art historians, curators, and artists researching Bruguera's practice but also for those seeking the

possibilities of using art to address immigration issues as they evolve over time—issues that, as this book will show, have been with us for centuries.

As Bruguera notes in her essay, her identity is personally connected to immigration and thus to the larger concerns of *The Francis Effect*. She became an immigrant when she moved from Cuba to the United States. She experienced firsthand the complexities of being identified as Latina or Hispanic, nuances that have also been explored in the mainstream media following the 2020 election, which revealed the Latin American immigrant population of the United States to be split into multiple ideological camps as wide-ranging and diverse as Latin America itself.

For the institutions involved in this project, our relationships to our publics and our communities also had to be negotiated with this socially engaged project. The curator conversation elucidates some of the challenges and opportunities that *The Francis Effect* offered to see more clearly our relationship to the public. For instance, this project didn't just address immigration; it also addressed the difference between the museum and the street as public spaces. It brought up the difference between private and public spaces as civic spaces and the difference between the museum and the church as civic spaces. In each case the artist and the curators of the project had to work in and around the laws and policies governing these spaces and whether they would allow the performance of art or political advocacy within their confines.

Taken together, Bruguera's essay, the curator conversation, and Our Literal Speed's contribution begin to show us how *The Francis Effect* navigates the spaces between art and politics. Furthermore, we see how Bruguera has addressed this space in her practice in general and questioned the ways in which art can engage with both the real and the symbolic. She has a number of ways of articulating this tension, including terms that she has coined, such as *Arte Útil* (useful art), *Artivism* (the combination of art and activism), and *Est-Ética* (the combination of aesthetics and ethics).[1]

1 For more on this see Claire Bishop, *Tania Bruguera in Conversation with Claire Bishop* (New York: Fondación Cisneros, 2020).

Another issue that arises from *The Francis Effect* is the use of socially engaged practices, specifically conversation, as a medium to negotiate politics. In her essay Bruguera talks about the challenges of short- vs. long-term projects. She notes that for an art project to truly engage a social and political reality it can't be bound by the artificial cycles of time that culture is usually based on and must allow for long durations that, if successful, may leave the artist and the institution behind. In the curator conversation Bruguera speaks about her critique of the artist as a do-gooder and advocates for models of antagonism to create truly radical forms of social and political change.

To complete the project, Bruguera has written a letter to Pope Francis—the first Latin American pope, who also made headlines by engaging with refugees in Lampedusa, Italy—requesting an audience to deliver the postcards in person. In doing so, she turns direct accountability to an institution that has tended to shun it. The artist suggests that the Catholic Church may, by helping those in need on a global scale and moving from charity toward public policy, become an agent for implementing long-term, economically sustainable change.

This book includes an essay by Bruguera that explains the genesis of *The Francis Effect* and its relationship to her other work on immigration, most notably *Immigrant Movement International (IMI)*. *IMI* was a project that was conceived in relation to the 2005 immigrant protests in Paris but became officially manifest in New York in 2011 with support from Creative Time and the Queens Museum. In 2018–19 it transitioned into an independently run community center. *The Francis Effect* overlapped in many ways with *IMI*, as Bruguera explains.

The book also includes a conversation between the curators from each of the three commissioning institutions and Bruguera. The conversation describes the project's development in the context of three different cities and curatorial frameworks, revealing the behind-the-scenes process in which a socially engaged artwork takes shape.

In addition to the artist's and curators' description of *The Francis Effect*'s evolution, three commissioned essays look at the performance from a critical perspective. First, Our Literal Speed places the work

in the larger context of Bruguera's oeuvre and her biography, arguing that both Communism and Christianity played an important role in her early development in Cuba. They also point out an earlier work, *Generic Capitalism* (2009), as an example of not only an artwork that uses conversation as a medium, like *The Francis Effect,* but one that critiques uncritical assumptions within progressive politics, phenomena which could be described as "preaching to the converted." This work, performed in Chicago, involved a panel discussion with former members of the Weather Underground and plants in the audience that challenged the speakers in ways that went far beyond the usual politeness of an academic event. Preaching to the converted is a stance that Bruguera adamantly rejects, and, as she and the curators describe, the discussions involved in the performance of *The Francis Effect* were truly political in the sense that they involved the negotiation of different points of view around the composition of our shared social reality.

Then the sociologist Saskia Sassen analyzes *The Francis Effect* in relation to the contemporary state of globalization and international migration. Looking at the conditions that produce systems of migration—including colonialism, economic development, climate change, ethnic cleansing, and drug violence—Sassen's analysis helps elucidate who is the migrant to whom Bruguera's project refers. As a case study for the complexities and nuances of these systems Sassen examines the Rohingya, a Muslim minority in Myanmar, and their plight in relation to not only the dominant narrative of religious persecution but also multinational land development. The other case study revolves around minors escaping violence in Central America—under circumstances tied to the takeover of small-scale farms by larger agribusiness, which led to migration to the cities, overpopulation, job shortages, and the rise of the drug trade and its related and inevitable violence.

Finally the historian Nicolas Terpstra addresses Bruguera's project in the context of the Catholic Church's history of political interventions and its attitudes toward exiles and refugees in the early modern world. He shows us that, with the Inquisition in the fifteenth century, the Church created refugees and that, with the Reformation

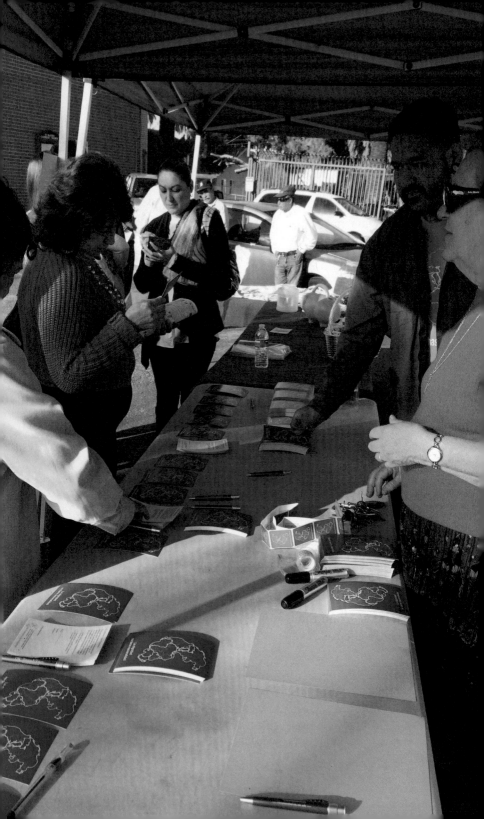

movements in the sixteenth, seventeenth, and eighteenth centuries, Rome became a refugee center for Catholics exiled from Protestant countries. He shows how the Enlightenment and the rise of nationalism compounded the political influence of the Church and how in the twentieth century it landed in the place where it sits now, in the borderlands between national sovereignty. Given this context, in which the "Catholic Church, of all modern churches, experiences most directly the global refugee crisis at its key sources," Terpstra offers a question: "How can and should it use that experience and its unique status as a state in order to address that crisis?"

Both Terpstra and Sassen help us to understand the histories of refugees and of the Catholic Church as a political actor. Their writings serve to contextualize *The Francis Effect* in histories of political economy. These are the social relations that Bruguera points to through *The Francis Effect*. Our Literal Speed tells us that "an artwork can *exist* before it becomes a manifestation of this social relationship, but it *can exist as art* only upon entering *the flow*." The flow, they say, is the way in which an artwork becomes a part of a series of social relationships. This book is meant to illuminate the complex web of social relations that are at stake with *The Francis Effect* and to produce a readership that can enter this flow and continue an engagement with a project that maintains urgent relevance to our contemporary politics.

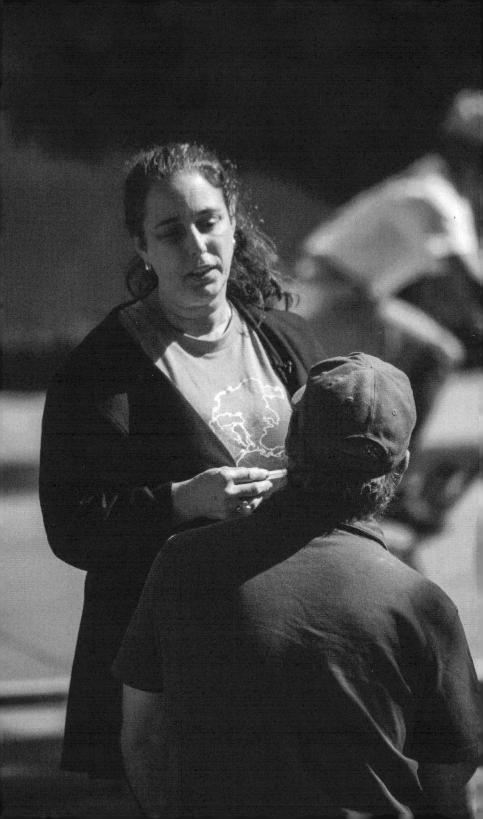

FROM *IMMIGRANT MOVEMENT INTERNATIONAL* TO *THE FRANCIS EFFECT*

Tania Bruguera

When I first arrived in the United States, I automatically became an immigrant. Being defined in such a way had two sides. For a Cuban to be an immigrant was a political statement, defined by the Cuban government, and, based on this, a judgment by those who saw Cuba from afar. I never wanted to be defined by someone else, even less by a government. Recognizing myself as an immigrant was to enter willingly into a political box that I was fighting to get out of. I always loved the freedom to be who I wanted to be, and that included not knowing who I was, which is not accepted politically. On the other side, I rapidly realized that the term *immigrant* was the American way to distance those who are not yet integrated into society and those who cannot use a hyphen when they introduce themselves. When you are called an immigrant a lot of prejudice comes with it and a lot of assumptions. If you are an immigrant you have not earned professional recognition. You are not called by your profession but instead by your country of birth. So it implies a double discrimination in terms of both the country that you left and the one that you have adopted.

I fought the immigrant label for a long time. I really wanted to be free, so why did I have to be defined one way or the other? I don't think this is an exception; in my experience so-called immigrants never call themselves this way. It is as if we adopted bureaucratic language to talk about people. Why do we allow people to assume things about others without knowing them?

This was the third time I felt this way. My first identity fight was being a female artist in Cuba, surrounded by macho artists. Then being defined as Latina, when I felt I had more in common with ex-Socialist countries than with Guatemala or Uruguay.

Before being labeled an immigrant I was (in my mind) an artist, who is a woman, who is a Cuban, a Latin American, which historically is different from Latinx. It is interesting that the United States forces you to deal with identity issues as soon as you arrive, and for this they provide several boxes for you to choose one. It is very hard for them to understand that we may be in between boxes as per our choice or that we are segmented in several boxes. It almost feels that they need clear definitions to know where to deposit their own fear of immigrants.

Although I recognize that I'm a privileged immigrant, it was interesting that all of a sudden people were putting me together with Mexicans, assuming that we celebrated the Day of the Dead, or that Cuba was in South America. It is painful to see someone's ignorance displayed with such certainty.

So I resisted for a long time this idea of being identified as an immigrant. I always wanted to have a transitional personality, to be in a transitional identity where you enter and exit nodes of tension. Then I went to live in Paris in 2005, and I saw on the news that the banlieue protests were happening close to where I was. I was walking with a friend, and we found a broken gun on the ground. When I took it and held it in my hands, all the aggression toward immigrants became unbearably real. It was clear that immigrants are left with only one option: violence (toward them and as the only way they are heard). It was very clear that the domination of the immigrant body was linked to the one exercised before over slaves.

I started thinking about why they're not allowed to articulate their own situation. They are either assigned an intermediary or silenced in such a way that they have to push back through violence. So I wanted to create a political party called the Party of Migrant People. Why don't these people have representatives in the Senate, occupying spaces of power where laws can be changed, instead of

other people talking on their behalf or using them for their own political agendas?

I started this in France, and people thought I was crazy because art people saw it as too political, too real, and not symbolic enough. But the people in politics said, "You're an artist, what do you know about politicians?" I was in residence at that time at Les Laboratoires d'Aubervilliers, and they put me in contact with people in the Senate who were not open to this idea either. Although I have to say that some immigrant associations were really open to it.

It was another time, when people distrusted the party system and saw politics as an exercise of corruption. After being used so often and for so long by those political machines, they felt entering the system to disrupt it was not an option; they opted for distancing themselves from it, for a more traditional *resistance* strategy. But of course, as an artist, I looked at the problem of political representation as a system that could be infiltrated. I started meeting with all the associations of migrants. They were so disappointed with politicians that it was hard to change their view, but some did.

This was supposed to be a party first located in Paris, the place of origin for liberté, égalité, fraternité, which did not apply to immigrants. But later we went in to work with people at the European Union. We had a lot of discussion about questions like, why don't you take power again? Why, if you have a complaint with the law, don't you think you should have the power to change the law? And why do you feel alienated from power? But in the end nothing happened. I was frustrated because the organization that I was working with wanted something clear. They wanted a performance or something concrete, and I couldn't deliver it. It was a long-term political process, and it was not something I wanted to be defined by me but by the community. Now this is actually the norm, but twenty years ago it was harder as an artist to say, "I do not know what form or what course the work will take because it is an organic collective process." I didn't have the tools to explain myself either because I was figuring it out.

And then Creative Time called me and they said, "We want to do a project with you," and I told them I'd just moved to Paris, I'd just left the United States. Then I said that the only thing I would go back for was to do a project that created a party of immigrants. And they said yes.

I wanted Creative Time to be in partnership with the Queens Museum. I noticed right away that Creative Time was an amazing group that I really admire, but its main audience was the art world. I understood that this could be a long-term problem, so I decided to partner with the Queens Museum. I knew Tom Finkelpearl, the museum's director at the time, and I went to talk to him about my hesitation at making a representational project only for the pleasure of the art world. He suggested I do it with them in Queens, and I just said yes. It was a perfect balance because they had a long trajectory working with the area's large immigrant community. This project was not to be displayed for the art world but to function within the community.

The first meeting I had with Creative Time was with lawyers who were very skeptical of the idea of a political party as art because in the US, nonprofit status doesn't allow for political campaign activities. They said that if we pursued the idea of a political party, meaning supporting a candidate, Creative Time could cease to exist: its nonprofit status could be revoked. We looked into the idea of a political action committee, a PAC, but ended up not pursuing it for the same reasons. We ended up calling the project *Immigrant Movement International*.

I was confronted again with the fact that I wanted the project to be real, not just a representation. I wanted the art to generate a political debate, a political situation, not just comments about it.

We talked about the difference between the US, with its two-party system, and Europe's multiparty political traditions, and how change traditionally occurred in the US under pressure from popular movements. The whole nature of the project changed. It was no longer about trying to allow immigrants to be in power but about social movements and community organization. In terms of power, this was the default position immigrants were always put in: asking for

their rights instead of having the power to change the laws that take away their rights. I know how to organize communities. I'm doing that in Cuba now. But organization is only a tool to do something else. I'm a political artist, not a community artist. I did not want to do community art. I enjoy when art can move things politically, when art actions put the government in crisis and they have to figure out how to respond—this is what I like doing as an artist, and it is my main research as an artist.

The immigrant community is in so much need and in such a precarious situation that it felt almost obscene to do this project just as art. These are people who were under constant attack, facing threats of imprisonment and deportation. In Europe the situation was bad, but it was not like it is now, with the recent xenophobia that has erupted around the refugee crisis. There is a different urgency each day in the lives of immigrants. The project changed from the irreconcilable propaganda of égalité to another as fraudulent as the land of immigrants.

When I was researching for the project in Paris, I was working with Algerians who had political training due to their long fight against French colonialism and with people from five countries in Sub-Saharan Africa, many of whom were politically aware, as well as Latin Americans who had left dictatorships. The group was not only really international but quite political. When you said you were Cuban, immediately you could start a conversation on international politics.

Then I came to New York, and, despite the fact that Queens is so diverse, the community that approached the project was only Latino. And for the Latino community, the fact that I was Cuban was a bit complicated. Cubans were the only people in the United States, until Obama changed the law in 2015, who could receive a special immigration status, due to the Cuban Adjustment Act. By law, Cubans were able to enter the US, and one year and one day after touching American territory, they would become eligible for permanent residency. In the meantime they got protections like social security and food stamps. For the community that came to the project, the papers that could grant them legal immigration status were impossible to get.

The Cuban community, especially in Miami, had been extremely arrogant with the rest of the Latino community. They felt superior without understanding that, as demonstrated when their legal privileges were recently revoked, their position was based on an opportunity that no other community enjoyed. I wanted to work on determining how this legal option could be extended to the rest of the immigrants.

Another idea connected to this project is that around 2010 and 2011 there were a lot of assumptions about community-engaged or socially engaged art. Some ten years later, many of these issues have been discussed, tested, and overcome. All the fights I had while doing this project are things assumed now when going into any socially engaged project. For example, the institution needed my name as a selling point. I never had a problem with the community about it, but for me the requirement was problematic. The budget was imagined just for events or for a short term, but these kinds of projects need multi-year support. There was a need for something "demonstrable," but how could I reconcile this demand while I was trying to build up an ethical ecosystem? I asked for people to give something—knowledge, a workshop, their time, etc.—to the community before they took from or participated in a program.

While doing this project I felt I had two assignments. One was with the art world, and the other was with the community-engagement, nonprofit world.

With the art world, I had to fight about political artwork (which has become more commonplace and accepted since the Trump administration). I started talking about *Arte Útil* and the idea that we need to use art as a tool instead of an end in itself. I had fights with people at foundations who did not understand the need for long-term projects and just wanted the work to be completed so that they could see results in three months. Things take time when you do social projects, and people in the arts are eager to develop quick opinions. I kept telling them that what they saw was not the project but only a moment of it and that maybe if they came back in a month, the projects would "look" different. I kept repeating, in every conference I attended, the need for new vocabulary to address contemporary art

and for a different approach to art criticism for these practices. It's often five years later that things start happening. For instance, after I left, a member from *Immigrant Movement* confronted a racist woman who was part of the community board and campaigned against her so that she was forced to step down. I think artists should step away from their projects at some point and leave it in the hands of the community, because socially engaged art is about empowering others.

We did a transitional project where we had an *escuelita*, or little school, to study socially engaged art and activism for around six months. Participants visited Thomas Hirschhorn's *Gramsci Monument* in the Bronx and Suzanne Lacy's project *Between the Door and the Street* in Brooklyn. This way, they had a context beyond their own. They were introduced to socially engaged art, and they also had community and leadership training. So we transitioned from an art project into a council-based project, meaning that the people who were part of the transition training were asked at the end if they were ready to be part of the council. It was a horizontal decision-making process in which the whole council decided where the project was going next. They were afraid at the beginning, but then more and more they took over. I thought that was great. I'm very proud of this process.

Recently, I was at an opening for an exhibition at the Americas Society, and a woman approached me and said, "Thank you so much!" I said, "Sorry, do I know you?" and she said, "No, thank you because I went to *Immigrant Movement* to use their services. They helped me with my papers." And this is somebody who is an artist in New York. This is the kind of artist for whom the work was done, and proof that the project had actually worked. It was not to be seen but to be used. Her story was not the only one: we helped some of our own community members with their papers and located some families in prison and stopped some detentions and deportations. Some of the kids of the project's members are at Juilliard and at Ivy league schools now, something their parents would have not imagined possible before their experience with *Immigrant Movement*.

I'm glad that *Immigrant Movement* is still working and that it is slowly becoming a political environment. Unfortunately, for that to happen

I had to leave the project; otherwise it would always be Tania's project. I kept a great relationship with some of the members—another measure of success that I use for projects of this type.

I'm not an artist who is interested in positive energy in art projects. I'm an artist interested in negative energy. I can recognize the power of positive emotions, and I recognize that they are an amazing tool. But to fight the system you need to show the other side of happiness.

My main idea behind *Immigrant Movement International* is to recognize immigrants as political beings. That is the first right that is taken from immigrants. I also wanted people in the activist world to be more creative. I felt that the activist world had become too predictable, in terms of outcomes, outreach, and engagement. Then Occupy Wall Street started, and I was extremely excited. I made everybody on the staff go to Occupy Wall Street. By chance, a Spanish friend of mine invited me to come to a meeting with activists from different groups at 16 Beaver Studio. After that meeting we went to another meeting, which is where Occupy Wall Street started. So by chance I was at the original meetings of Occupy, but I was more like an observer than a participant. It was an educational experience.

But back to the question of time. The five-year cycle comes from Cuba. Because in socialism we have the *quinquenio*, a cycle of five years of economic and social plans. I said to Nato Thompson at Creative Time from the beginning that *Immigrant Movement* was a five-year project. At first they said no, the most they could do was six months, maybe nine months or a year—the maximum they'd done was with Paul Chan's *Waiting for Godot* in New Orleans. So then they said "Okay let's do a year and then see what happens." We had around $150,000 for the project. Of course, a large chunk of that went to insurance and paying for the space and salaries (mine was minimum wage). But we went from that to zero after the next year.

A lot of people criticized the project. And I feel like some of the criticism made sense, but some may have had to do with a perception of Creative Time that was transferred onto the project by those who never came to experience it firsthand. They robustly promote their

projects, and I learned through the experience that press coverage for a community-based work may be better saved for when the press are useful to the community and not at the beginning of a project. One of the worst examples of the project's early press was a New York Times article by a journalist who didn't understand anything.[1]

He thought the whole point was to live with immigrants, as though I wanted to see how it felt to be poor . . . which I was! I was going to lose my apartment because I didn't have money to pay rent.

The thing is that social projects are environments into which viewers can project themselves. The community can project itself and look at themselves differently, but the racists and those who have no relation to the work can project themselves in it, too. That first year was about setting up the ecosystem, an ethical ecosystem. A lot of people came because the project was so well known and open. I had to stop many by telling them clearly, "You are not here to photograph the community and use these images for your next show." In order to enter that space, you needed to give something. If you're going to take something, give something. So that's why, after that *New York Times* article, critics who wanted to write about *Immigrant Movement* had to give a lecture or give a workshop or do something there. Because the project is not about what you see, it is how you feel. It's not something where you put in five minutes and get it. It is about how you create a community that didn't exist before. And to understand how that works, you have to become part of it permanently or at least create your relationship with it.

After the first year of the project, what happened was very beautiful. I told the women and other people leading workshops at *Immigrant Movement* that we were going to close. They organized and went to see Tom Finkelpearl. Tom came to *Immigrant Movement* a lot and really enjoyed popping in to see what was going on and to be a part of it. So they organized, and they went to see Tom. That's how

1 Sam Dolnick, "An Artist's Performance: A Year as a Poor Immigrant." *The New York Times*, May 18, 2011. https://www.nytimes.com/2011/05/19/nyregion/as-art-tania-bruguera-lives-like-a-poor-immigrant.html.

the museum continued its long-term commitment, and in a way the project became inseparable from the institution. He committed to pay for rent, insurance, and all the office supplies. I had to come up with the rest. So I told Anne Pasternak, the director of Creative Time then, that we're going to continue, and she supported the project with $10,000 the first year and $5,000 the next. Scaling down and not having the pressure of the outsiders made us more focused. But it was tough for me personally because I had to find money to pay people. We applied for a lot of residencies and grants. We didn't get anything, because the work was too political for the artistic programs, and for the other ones it was too artistic. So I didn't get anything, and then A Blade of Grass, whose mission is to fund socially engaged art projects, began supporting us. We never applied, but it was great to see someone thinking about funding differently.

So now, I'm gone from the project, but the Queens Museum continued to support it until *IMI* became Centro Corona, an independent community center. That was part of my responsibility, to make sure that the Queens Museum and its new directors kept their commitment to the project, the space, and the budget.

Immigrant Movement International is not only this project; it's a series of works. It's also the context for *The Francis Effect*. Pablo León de la Barra invited me to *Under The Same Sun: Art from Latin America Today* at the Guggenheim. They wanted to include a piece that I did in Cuba in 2009, *Tatlin's Whisper #6 (Havana Version)*, and I said, "Let's just do something about immigration." And I proposed this performance.

The Francis Effect is very different from *Immigrant Movement* because it is a short-term piece and openly political. It has a supposed end, a grand finale when the pope receives the postcards, which of course has not happened yet. The pope was elected in 2013, and I wanted to remind people about the political dimension of the pope—he's the head of a state. *The Francis Effect* was about proposing something completely absurd, as absurd as borders are. It was a purely activist tool, a signature campaign where you are not asking for your rights but for the rights of others. If *Immigrant Movement* was for the

thousands of people who went there, *The Francis Effect* was just for one person, the pope. But the more people participated, the more personal it became. At *Immigrant Movement* we were working within the constraints of an identity that was given, whereas *The Francis Effect* is about understanding that this identity can be easily reconstructed or redesigned if there is a will.

The Vatican is a kind of conceptual extraterritorial state that was set up by decree. Because what is there, are offices of something that is intangible: faith. What if people all over the world can be part of one place, this one place that serves people from all over the world?

Also, the pope is an immigrant himself. When he went to Lampedusa and put immigration on his agenda, he invited twelve immigrants to return to Rome with him. One thing that is important to mention is that the Catholic Church has been a huge ally of immigrants. But this project addresses the difference between charity and providing a legal and permanent solution.

There was a subtext in *The Francis Effect* about tourism, too. The Guggenheim is a major stop for tourists in New York, and I wanted visitors to think about the fact that they had the freedom to come and go. People want tourists—they think they support the economy—but they don't want immigrants, nor do they recognize the major economic impact that immigrants have. When you are an immigrant, they don't see the contribution you make.

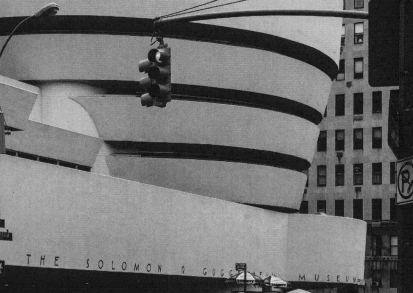

THE SOLOMON R GUGGENHEIM MUSEUM

CURATOR CONVERSATION

Lucía Sanromán, Noah Simblist, and Christina Yang with Tania Bruguera

New York, July 2016

NS: The goal of this conversation is to track the narrative of *The Francis Effect*. How did it begin? How did it manifest itself in the different cities?

LS: In 2012 I was curious about artists that worked with policy issues. I was in Mexico City that summer, and Tania was working with the Sala de Arte Público Siqueiros. I went to meet her for the first time, and we started talking and very quickly developed a rapport. Then, as the project for the *Citizen Culture* exhibition began to take shape, I invited Tania to be part of that exhibition with *Immigrant Movement International* (*IMI*).

But the question always was, how on earth do you present a project that is contextually driven? It's not that the issue of immigration is specific to context, but the whole conditions of *IMI* were so particular. They had a relationship to institutions and to a specific neighborhood in Queens. We had four or five meetings over the course of a couple of years about how to do that.

CY: How did you go from that to this idea of approaching the pope? I think that started with the two of you, right?

TB: That started in 2010. I was invited by the curator Eugenio Viola to do a piece for the Madre Museum. It was a performance festival, and I presented a press conference to announce a dream I had about

Pope John Paul II. He gave me a message, and I felt it was more important to deliver the message than to actually do a performance. That's how the relationship with the pope starts. But then I actually had a dream about the current pope, who is the migrant pope—think of his visit to Lampedusa, Italy.[1]

LS: I remember when we first had a discussion about the dream that Tania is describing. Anyway, in 2012–2013, we went to Tijuana to see if there could be some kind of contextual, more operative version of the office of *IMI*. The discussion turned into a critique of the systems of nongovernmental organizations and activist organizations around the issue of immigration—how much they help or don't help. We went to a couple of homes for undocumented immigrants that returned to Tijuana from the US. Nongovernmental organizations that work with undocumented migrants do amazing work, but their job is actually perpetuated by the fact that they are needed. In other words, it doesn't really serve their purposes to . . .

TB: To be successful.

LS: During this trip with Tania these ideas were percolating in her mind and she came upon the idea of what would happen if one could address the pope himself. He has this exceptional capacity. The Vatican has a specific governmental authority that has a historical capacity to make exceptions to laws. For example, it was the pope in the fifteenth century who allowed the Americas to be divided between Portugal and Spain in the Treaty of Tordesillas.

1 In July 2013 Pope Francis visited Lampedusa, an Italian island about eighty miles north of Tunisia that serves as a major entry point for the thousands of African refugees coming to Europe. "While praising volunteer associations, law enforcement officials and residents of the island for the assistance they have provided to the migrants, the pope criticized the 'globalization of indifference' that he said was widespread among too many others. We 'have forgotten how to cry' for migrants lost at sea and 'take care of each other,' the pope said in his homily." Elizabeta Povoledo, "Pope Offers Mass on Island Beacon for Refugees." *The New York Times*, July 8, 2013. https://www.nytimes.com/2013/07/09/world/europe/pope-offers-mass-on-island-beacon-for-refugees.html.

TB: I think it fell into a theme in all of my work, which is about taking a situation of power and demanding something. What triggered the project was the event in Lampedusa. But I also thought about the idea that the Church is an enterprise of charity, and our charity is not what immigrants need. Immigrants don't need food to eat for one day. They need the empowerment of papers. The only thing they need is papers. So we started dreaming and came up with the project as something to say.

Also, I was interested in the fact the Vatican was an exceptional country because it was created that way. It was an abnormality in relation to other nation states. The Vatican is a nation state that is not defined by territory but by religion. It was interesting to me that the Vatican was not about traditional nationalism. It is a nation that says you belong here no matter where you are from, but you have to believe in something. So I thought maybe countries should be organized in other ways than territory.

NS: It's interesting that when you describe the beginning of this project, you wanted to critique the NGOs that work with immigrants on the San Diego–Tijuana border. By performing the role of the activist, the image of the NGO worker, one reading of *The Francis Effect* could be that we should all take on this role. But on the other hand, it could also be read as a critique of this role, by saying that none of these NGOs can do anything effective, but the pope can actually do something.

TB: Exactly.

NS: So, then how did this progress? What was the chronology?

CY: So, chronologically I think she went to SMU first before we started talking in New York, right? Because Tania came to me and said, "I don't know what I'm going to do, but I already have two partners."

NS: Yes, but it really began here in New York.

TB: Yes, this is the first place where it happened.

CY: I knew that we were going to acquire one of Tania's works, *Tatlin's Whisper #6 (Havana Version)*.[2] Pablo León de la Barra also wanted to commission a new piece. The idea was that it was going to be live and embodied in some way. But we weren't going to stage *Tatlin's Whisper*, because the political conditions didn't seem appropriate.

TB: Yes, because you can say anything you want here! I remember I was joking with Pablo and said, "I think the only thing we can do in New York is set up *Tatlin's Whisper* and ask people to reveal all the gossip of the art world, because *that* is forbidden."

CY: But you had an idea early on about the pope and the Church. We looked into doing something around doves. I think you were very interested in the drama—the space and spectacle that the Guggenheim provides. Also, you were very interested in having a visual signifier for the project. You had the Pangaea graphic. At some point, Pablo said, "You know, just do the letter-writing campaign. We'll do it on the sidewalk."

LS: So, at the same time as Tania was talking to Pablo at the Guggenheim, we were also figuring out how to do the letter-writing campaign. I was working with the Mexico City–based designers Buró-Buró to do all of the graphics for the *Citizen Culture* exhibition. Then I came to New York and met with Christina. There was also an idea that there would be T-shirts and all of the different parts for *The Francis Effect*. I think the Pangaea was an idea that Tania had already drawn.

TB: Yes, we had an early version of a Pangaea postcard with *Immigrant Movement International*.

2 *Tatlin's Whisper #6 (Havana Version)* was originally performed at the 2009 Havana Biennial. Bruguera provided a temporary platform for the free speech normally denied in Cuba. Members of the exhibition's audience were invited to take the stage and speak uncensored for one minute, after which time they were escorted away by two actors in military uniforms. A white dove was placed on each speaker's shoulder in allusion to the one that landed on Fidel Castro during his first speech in Havana after the triumph of the 1959 revolution.

LS: What we discussed then was the capacity that the Guggenheim has to synergize attention around the project and to gather the signatures. What became really interesting, and in a way almost prefigures the kind of social network that has gathered around *#YoTambiénExijo*, is that the vast majority of the people who signed were art world people.[3]

TB: No, I don't think so. For the Guggenheim it was very different. I remember a few things. First, I wanted the color to be the same color as the UN blue. Also at some point I said that we have to go outside, because it should look less like the Guggenheim, because if people see the setting as the Guggenheim then they won't think that it's real. I wanted to emphasize the public reality of the project, and actually a lot of people thought it was a real conversation, which is great. And actually I think that we gathered almost twelve thousand signatures at the Guggenheim. The majority were not artists but tourists. It was great because we had people from all over the world, which worked really well for the project.

NS: Do you remember anything about those conversations?

TB: I remember this guy who was extremely racist, like Trump. He said, "You have to get those immigrants out of here because they take all the resources." Then his girlfriend arrived, and she's Asian and doesn't speak English very well! That was something that shocked me. Another thing that was interesting was that there were some people from the Vatican at the beginning. One who worked there, but he said that he couldn't sign. One was a priest, and [there was]

3 *#YoTambienExijo (I Also Demand)* was a project that Bruguera initiated in December 2015 after Barack Obama and Raúl Castro announced the opening of diplomatic relations between the US and Cuba. Bruguera published a public letter to Obama, Castro, and the pope, announcing that she was going to restage *Tatlin's Whisper #6 (Havana Version)* in Havana's Plaza of the Revolution so that Cubans could talk publicly about their vision of Cuba's future. A crucial component of this project was a social media campaign using the hashtag #YoTambienExijo. She was unable to complete the project as she was arrested by Cuban police in Havana on December 30, 2014.

someone else who came with his family. He was an administrator at the Vatican, and we had a really good conversation. We explained why I chose the pope for this project and about the capacity of the imaginary that could be used by him, and they all wished me good luck. Then I remember a woman who was Catholic. She was very mad because she said that the pope is not a politician, the pope is not political.

And at some point during the performance, there was a crisis in the news about the kids from Latin America coming into the United States.[4] I think a lot of things that were in the news influenced people's reaction to the project. I remember at some point there was a crisis in the Middle East in Palestine.[5] Some people said yes, but others said "I'm Israeli, so no." They asked, "Which refugees?"

NS: Yes, because in the case of Israel-Palestine it is a very politically contentious question to ask: Who is a refugee?

CY: I remember also that when we were talking about doing a performance, Tania said, "I haven't done a performance in a long time. But you said one hundred days? No problem." You were committed to it. Tania said, "I want to do a performance, but it's going to be durational, it has to be really demanding. I want to be out in the street." So, in the beginning we said, "I guess we can't stop her." But then we had to figure out things like weather and are people going to be here when the museum is closed? So over time we figured out the best times. Also the press wanted to see her. They asked, "When is she going to be there?" We had to figure out a way to organize it a little bit more like a theater piece. The performance was every day. Even some from *Immigrant Movement International* came in and did some canvassing.

NS: So, how did the volunteers work?

CY: Just to clarify, they were paid.

4 In the summer of 2014 there was a surge of unaccompanied children from Central America into the US.

5 The 2014 Gaza war, also known as Operation Protective Edge.

NS: OK, so how many people were there, and how were they trained?

CY: Tania trained them. We had a pilot day, and Tania, myself, and two staff members did the piece. We ordered the posters and ordered the T-shirts and the tote bags and the stickers.

TB: I remember that we had a conversation with the woman from visitor services.

CY: Yes, we had meetings with visitor services, with legal, with security. We had to figure out how the frontline staff were going to talk about the project. We developed an FAQ. We did a script for how to approach people, how to get to the question relatively subtly, but quickly, and then listen to them and then move on. Because at some point Tania said we have to get a hundred signatures a day. So not every signature was a conversation. Sometimes a group would come. For instance, [performance artist] Karen Finley brought her class. But every day Tania had good conversations. There was one with a woman who was an artist. She said, "I came to see this show, and if you hadn't told me this was an artwork I would sign it. I'm very political, am very involved in social work. I'm very involved in immigration, but because you told me it was an artwork I'm not going to sign it. Because that would ruin it for me."

Tania was like a slow shark. You're looking to have a conversation. In the end you have to commit to having a conversation and listening. But you also want to wrap it up because you have to get your signature and move on. So each canvasser or performer had their own technique.

But there was also the time when one performer had a hard conversation with somebody. She had a conversation with a guy who was very aggressive and said that this will never work, how can you imagine that the pope will ever do this, and he shut her down. She was traumatized by it. She said, "I think I have to take a break," and I remember going to our curators and sa[ying] that we have to shut the piece down for an hour because she had a hard conversation. And that led me to think about the piece as an object. It needs to be protected. It needs to be contained and taken care of.

NS: So, is "it" the conversations?

CY: No, the performers. They were vulnerable to anything that people would say. So even though the script said that this is an artwork by Tania Bruguera, it's in the show at the Guggenheim Museum, even when it was contextualized and framed—when they realized it was about immigration, that's when difficult interactions came up.

TB: That's an interesting point. There was a very interesting reaction to that script, because people heard whatever they wanted to and they couldn't hear anything else. But then there were those that signed and didn't care. There were cases in which one person from a group would sign and then everyone from the group would sign.

NS: But that's good because you wanted signatures, right?

TB: Yes, but we also wanted this to be kind of a campaign. We had lots of good conversations, but at some point we had to focus on the numbers. In that sense the project was very political.

CY: Because we had this picture in our minds that a big box of postcards was going to arrive at the Vatican with fifteen thousand signatures.

NS: So, at the Guggenheim this project occurred within the context of a group show, *Under the Same Sun: Art from Latin America Today*. It wasn't a solo project. It was a project that was framed in relation to Latin America.

TB: That's why it was appropriate.

CY: Yes, because the pope is from Argentina.

TB: I wanted to do a piece that was connected to the United States, and one of the main subjects for the US is immigration. That's the one thing that I didn't see in the show so much.

NS: So, then, Lucía, how did the transition happen from New York to Los Angeles?

LS: Well, there was a group of people working with the curator of education at the Santa Monica Museum. And we were very conscious of the change of scale from the Guggenheim. Also, the Santa Monica museum didn't have a lot of foot traffic. Like everything in Los Angeles, you have to drive and park. So, working with the curator of education and a group of volunteers, we worked on figuring out in what churches the canvassing could take place.

That became an interesting thing. In fact, I don't think we were very effective at canvassing in the exhibition in *Citizen Culture*. Many of the people that we met during the visits to the churches were nervous. We went to meet a Jesuit priest from [a Jesuit-affiliated university in Los Angeles], to get permission to canvass at the university, because of course it is Jesuit. It became a very interesting debate, because he questioned whether legally the pope could do anything about immigration. He completely understood that it was a provocation. But they wouldn't let us do it. He didn't quite say no, but he also didn't quite say yes; it was more like, "Come back."

CY: We also thought about going out into the city. We went to a lecture given by the bishop of New York at a church right down the street from the Guggenheim.

TB: This is where we found the title. The lecture was entitled, "The Francis Effect."

CY: We were thinking about canvassing at schools and going out into the city. But then there were people at the museum that said that it didn't sound like an artwork and worried that there might be legal problems. So then we decided to stay here at the Guggenheim. We had to ask, what was the frame that could be most effective? And the most effective framework actually was the art context, because the artist had control over it and it could be in this in-between place—between canvassing for signatures and a hypothetical gesture. Tania has talked about this before, about how the museum visitor transforms into a citizen. So the sidewalk in front of the museum was a space where that could happen.

LS: In Santa Monica, we had a display where people could sign the petition. We had to ask, "How does the work operate most effectively in a political sense?" There were these two figures at play: Tania the artist and then the institution. You could easily just pick up fake signatures outside of church. But because we were asking for permission then something interesting happens.

NS: Well, there is a whole story in Dallas about this. Because we didn't have an art institution, like a museum, as a base, the performance had to occur in the city. So it wasn't going to be an extension of an exhibition. The performance on the streets was the project. We went to the Texas State Fair. We tried to go to Klyde Warren Park in the Dallas Arts District, but we had to stay on the sidewalk, because the park is private and wouldn't allow us to canvass within its borders. Nobody in the city realizes that it's actually private. But this is an interesting dimension to the project, because it revealed this question about the privatization of public space, how civic action is possible in private versus public spaces, and that got mirrored as well when we went to the church. Because we first tried to ask permission. When Tania arrived in Dallas, that was the first place we went, because the Cathedral Guadalupe is in the arts district and is the largest Catholic church in the city.

TB: I think it does six masses a day. And they deliver them in Spanish and English.

NS: Yes, and so we tried to get a meeting with a priest, but we couldn't get a meeting ahead of time and so we tried to hijack him in the hallway. We talked to him for a little bit, and he said, "I'll take the information and we can see"—but then eventually he basically said no.

TB: I remember in the Mass, he said, "There are people outside the church asking you to sign this postcard for the pope. They're not part of this church, and we don't want you to sign it."

NS: It was so fascinating, because we had to do the same thing with the church that we had to do with the private park. With both the

park and the church we had to stay on the sidewalk, because the sidewalk was public property. Both the park and the church had security that was monitoring this invisible line.

CY: We had that protocol, too. So if anyone got into trouble, they could talk to security. Our security was supposed to be looking out, because even though they were stationed inside, they came outside every now and then.

TB: But the one thing that is interesting is that at the Guggenheim it was a piece that involved talking with everybody. We acted like citizens taking care of this issue, but then in Lucía's exhibition it was more about people who care about politics. And bringing this subject of religion to politically engaged activists was very nice to do, because this is not the thing that most activists think of. And then when we went to Dallas, I felt that this was the target audience—the people who are actually part of the religious community.

CY: Yeah, it was interesting the ways in which the piece enacted different kinds of change. You know the Guggenheim was very much one-on-one. It was about shifting people's psychological state, to have them think a little differently. And then in Santa Monica, the theme of the exhibition was policy, and that's another kind of political change. And Dallas was very much a performance . . .

TB: Dallas felt like a place that is really against immigration.

NS: Yes, there were different audiences that we engaged with. So, when we went to the Texas State Fair we were a group that included ten graduate students, and we stationed ourselves at the entrance. The students were trained, but I was a little afraid for them at certain moments because the Texas State Fair brings people in from all over the state, even though Dallas is relatively Democratic and progressive. And some of them had some very tough conversations. No one ever got physical, but people were cursing at them.

LS: Something that is so interesting is that the Guggenheim iteration was a durational performance that put the artist in this kind of

constant state of being in contact with the public. Tania, you were there with a sea of people for one hundred days. But in Santa Monica, it was much more of a political gesture. And it really was much more focused on the virtual aspect of the project. And then with Dallas, it was very brief and didn't have the protection of the art context.

NS: In that sense it was activism that was read as activism.

CY: That's the reason why we developed the script. It was to try to get to the point as quickly as possible. What does the artist want? What is this project trying to accomplish? We needed to just say enough to people to offer a framework for the project.

NS: And as Lucía said, there were two frameworks: the artist and the institution. But in Dallas it was unclear that Tania was the artist. Even when we followed the script, the students said, "This is a project by Tania Bruguera," and it meant nothing to most people on the street. Because there was no institution and no optics for these frameworks, so all they heard was the message about immigration. The students started depending on their own national background or ethnic background. They also became frameworks for the project.

So, were there other performative instances in Santa Monica?

LS: Yes, there was some canvassing that happened with a group of volunteers that were graduate students from the curatorial program at USC. But every time I asked them how many signatures they got, there was always a dramatic story about not being able to do it as well. There was frustration because in Los Angeles you have to drive forever, so it's not like canvassing on the street. Also, they did try to address the immigrant population, but they weren't successful because of the suspicion of the immigrants. Many didn't want to sign their name.

TB: It's important to remember that we wanted to make it as legitimate as possible, so that the postcards could be taken seriously. We asked for people to sign their name, country, address, email, and so on. We also had postcards in both Spanish and English.

NS: The other place we went to in Dallas was the Fiesta supermarket. This is in Oak Cliff, a neighborhood of Dallas that's historically composed of mostly Mexican immigrants. There are quinceañera shops just down the street. The population that shops there is mostly Spanish-speaking. So they weren't put off by the project. They understood the question, but some were afraid to put down their address. And then the manager and security eventually asked us to go, but they were so apologetic that they put it off for a while.

So, Tania, what is that story when you actually went to the Vatican?

TB: That's for another project.

LS: This is actually very interesting to me. The child of the revolution having dreams about the pope! One piece echoes another piece and echoes another piece, and all are about change in the social arena.

TB: It is true. I remember now that I was invited to a performance festival in Venice. On Wednesdays the pope makes a public address, and I went and left two *Francis Effect* T-shirts and two blank postcards with a note in Spanish that said, "We are suffering."

NS: So, what is this project now? To some degree the audacity of the initial proposal suggested that it ended when the pope received the postcards as a petition in order to consider it seriously as a policy proposal. But was this just speculative? Do we think of the project as something that stopped when these three institutional contexts in New York, Los Angeles, and Dallas ended the platform under which *The Francis Effect* was supported?

TB: I think that, unfortunately, this is why every project to do with immigration is so sad. I had my idea for the party of immigrants in 2005, and it's now 2016, and we're still at the same place. Actually, we're in a worse place. I think that the kind of demand and urgency for the project is still there. For me the project can keep going, and until we are in the presence of "his holiness" and give him the postcards it's not completely done. But the other thing that is interesting is that the pope has become more and more engaged with immigration as an issue.

CY: Yes, other people have been talking about the idea that the pope should just grant citizenship. Not that we are taking credit for it, but one dimension of *The Francis Effect* is that it is a rumor that suggests something, a gesture that is out there that might actually make its way to the pope.

TB: Did you hear that he brought ten or eleven Syrian refugees to the Vatican on his personal jet? I still think that *The Francis Effect* was a critique about charity. It was calling out the Church, the whole institution, and asking them how they will really solve the problem. You have so much power, so much money . . . is that enough? Is symbolism enough?

NS: And when you say "charity" and "calling them out," is this calling out the Catholic Church, or is it the more general notion of Christian charity that could go beyond just Catholicism?

TB: I mean the idea of charity as "I feel good about it," instead of what the person needs. Because a lot of people think that they are a great person because they gave a person a shirt. But that person has a life. And it's something that is actually similar with artists who think that "Oh, I just did this symbolic thing, and I have solved the problems of all these people." No, you have not. You have done something for awareness or for solving a little part of the problem and not *the* problem. So I think that in a way the piece is a critique of the Church but also of the artist and the activist who perpetuate the problems that they are supposedly addressing.

And it's also about calling attention to the fact that the Church is a political institution. If I think that this was a very important part of the piece, it is, and this pope has been the most openly political of all, like intervening with the Cuba-US relationship, intervening with the Colombian situation, etc.

NS: This ethical issue is something that comes up in social practice discourse all the time. For instance, another thing to mention is that when you came to [Houston-based artist] Rick Lowe's class in Dallas and you tried to recruit students from his class, there was resistance from the students to your project because it was unclear to them what

your position was in relation to those that would supposedly benefit from the project. I think that they expressed a worry that the project wasn't doing enough good.

TB: And what is doing good? Doing good is to give the person what they need.

CY: I think that that's a really interesting topic that we could talk another hour on. But I think that the point is that in Tania's work there's always the question, when is the art not enough? When is it actually real? But I think that Tania's work always asks those questions, and also what is an artist, and she is always trying to redefine that position. When do you want it to be effective, and when do you want it to be activated? Her work often parallels social practice, and I think that's one reason why that genre has attached itself to Tania and her work but—

TB: But it was a critique in a way of that, too. It was a critique of the genre itself—the genre of the social good and the socially engaged artist as a do-gooder.

NS: This reminds me of when you were talking about finding the NGOs in Tijuana that lived off of the problem of immigration at the border.

LS: Well, it's not just in Tijuana. It happens in many places, but it's much more clearly evident in Third World countries where the problems are so radical. But what would impact happen to all the pro-immigration NGOs in the US if it was resolved? They would have to undo themselves.

TB: But what is also interesting is how much of the NGOs' money goes to support the institution and not the projects. It's the salaries, the lights, and the rent of the space, but then they don't have money to actually do the projects.

NS: A French anthropologist, Michel Agier, wrote a book about this called *Managing the Undesirables*. He talks about this exact issue

in Africa, specifically with regard to refugees. I found out about it through [artist/architects] Alessandro Petti and Sandi Hilal, who found his ideas very influential to thinking about the Palestinian refugee camp. They talk about the problem of the camp as an industry, and the Red Cross, the UN, NGOs that manage these camps and the fact that they need to sustain themselves by actually replicating the very issue they are supposed to be there to fix.

LS: I find that when we consider *The Francis Effect* in terms of a critique of social practices there are certain tropes of social practice that we might need in order for us to recognize the project as such. So, for example, the artist must be in a relationship to a specific community. The artist oftentimes is from elsewhere, although the best projects are actually internally produced. But in fact, there are so many social practitioners being educated in different schools that it's almost impossible to actually have the project be indigenous. There are also aspects of discursivity that are attached to community organizing practices so that the best social practitioners are really good community organizers, creating consensus about a variety of different people through talk and discussion.

But in this case what is so interesting is that people are performing a political function that is part of a specific political system while canvassing for signatures that are supposed to have a certain effect in policy. Yes, there is a level of convincing someone but it's a very simple request: I just need your signature. And this makes you committed. You put your signature to an issue that you might think about once in a while. The act of signing momentarily brings you into that spectrum, to think through what it means to be an undocumented immigrant. This isn't the kind of touchy-feely social practice.

NS: Yes, and to be effective, to follow Tania's concept of *Arte Útil*, you have to get the numbers. But then if you spend too much time on the numbers then you don't really—

TB: Educate them. This was not relational aesthetics. It was: give me a signature. It was not to hang out.

NS: Are you critiquing a certain kind of social practice work?

TB: Yes. It was about this idea of people feeling that they are doing good, whether you are an artist who does socially engaged art or whether you are a Good Samaritan that has some money. It was about this idea of doing good as charity versus solving the problem, and how hard that is. It feels better to give somebody a short-term solution. If you are thirsty, take water, or if you are poor, please take money. That is a gratifying act for you, but to really effect social change on a policy change is not gratifying at all.

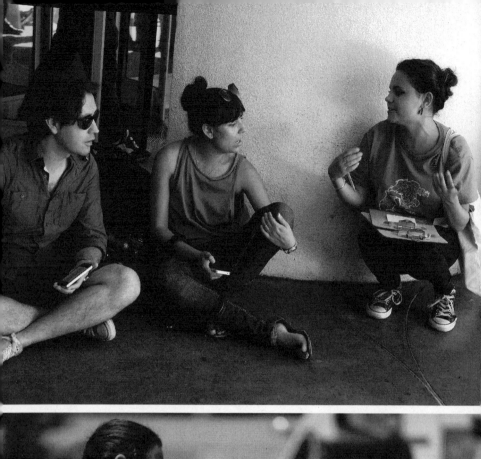
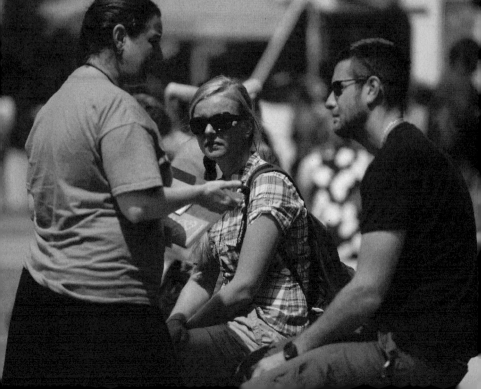

NOTES ON TANIA BRUGUERA'S
THE FRANCIS EFFECT
Our Literal Speed

"I think we are living in a time of global totalitarianism..."
—Tania Bruguera[1]

Tania Bruguera began making art in an atmosphere saturated with Communism and Christianity, and that environment, the everyday of the Republic of Cuba, has stuck with her. And it's stayed with her art, too. The shadows of church and state never quite recede when you encounter her productions. Appropriate, then, that notions of self-sacrifice for the community and the cultivation of collective social responsibility circulate throughout Bruguera's art from its beginnings, though it is only with the appearance of *The Francis Effect* (2014–ongoing) that Bruguera moved from an implicit awareness of her art's imbrication within these (apparently contradictory) value systems toward a more explicit working through of the systems' potential mutual illumination.

The Francis Effect developed out of Bruguera's five-year undertaking, *Immigrant Movement International* (2010–2015), a community-based art project in Corona, Queens, but more generally the work embodies Bruguera's long-running practice of *Arte Útil* ("useful art"). Often invoked as shorthand for her working method as a whole, *Arte Útil* imagines art as *being* something rather than *being about* something.

1 "Creo que estamos viviendo en un momento de totalitarismo global..."
 "Interview with Tania Bruguera" in Hugo Huerta Marin, *Portrait of an Artist* (Montreal: Anteism, 2017), 63.

Just listen to how Bruguera describes *The Francis Effect*: "Basically what we're doing is—outside the museum and in other places as well—collecting signatures, asking Pope Francis to give Vatican citizenship to all the undocumented immigrants in the world, and refugees."[2] Thus, by *being something* (the collection of signatures on a petition to a public figure to grant citizenship to living and breathing refugees), Bruguera's art compels viewers to compare their experience of her work not so much with previous engagements with artworks, but rather with experiences drawn from other areas of their lives. On this score, Bruguera has stated, "I'm very happy about *The Francis Effect*, because now art in the social sphere has to take into consideration all the energies and all the aesthetics that the social sphere has on its own, beyond the arts."[3] In this formulation, one sees that Bruguera's projects do not focus on producing newness, but on learning to hear vibrations already humming in society at large.

If, on the one hand, *The Francis Effect* attempts to achieve a fundamental ambition of Communism—to produce a form of egalitarian, global citizenship diametrically opposed to *Blut und Boden* atavism—on the other hand, it proposes to employ the hierarchical ecclesiastical structure of the Roman Catholic Church to achieve this progressive goal. To say the least, it's an odd pairing, but one strangely consistent with the logic of Tania Bruguera's art. Typically, her projects invoke psychic situations related to what Bruguera calls "the civil aspect of society" (work, politics, faith), rather than art's more familiar mental terrain of entertainment or leisure, yet Bruguera does not interpret her work as being narrowly utilitarian in thrust. Instead, she suggests that her art works best when it becomes a form of improvisational toolmaking. In this scenario the artist and the public must work together to "use the art" while both parties remain unsure exactly how the tool might function.

In Bruguera's art a process of trial and error becomes a source of both aesthetic and ethical "effects" which ideally coalesce in what the artist

2 "Interview with Tania Bruguera," August 15, 2014, https://www.guggenheim.org/video/tania-bruguera- on-the-francis-effect, accessed 10 May 2018.

3 Ibid.

neologistically evokes as *aest-ethical* experience.[4] Such works aim to produce an interval during which a variety of capabilities and possibilities are temporarily amplified, as in a work such as 2009's *Tatlin's Whisper #6 (Havana Version)*, in which Bruguera's Havana audience is invited to take the stage one at a time, to speak uncensored for exactly one minute. Then they are escorted from the microphone by two actors in military uniforms. A white dove is placed on each speaker's shoulder, a lyrical reference to the dove that landed on Fidel Castro as he gave his first speech in Havana following the triumph of the 1959 revolution. With its dramatic staging of brief yet riveting expressions of rhetorical insistence, this artwork produces unforeseeable circumstances within the public sphere. The work, then, is not *about* freedom of speech—the work *is* free speech.[5]

The social and psychological effects of "global totalitarianism" appear and reappear throughout Bruguera's art, though the artist's use of this phrase has much less to do with the immobile dogmatism and perpetual surveillance of Cuba's bureaucratic state socialism, and a great deal more to do with the dictates of a constantly expanding, hypercharged, globalizing capitalism and its overt exchange of Judeo-Christian ethics for a strain of all-encompassing (one might say "totalitarian") "market morality."[6] In this sense—from a certain point of view—it could be argued that neoliberalism in its post-1989 phase does not represent a school of economic theory so much as a new religion that proposes "market values" in place of traditional notions of ethical responsibility. Most important, such developments have

4 "My concept of beauty manifests itself in an ethical gesture that proposes another way to operate in the world, and I call it aest-ethics." "Interview with Tania Bruguera" in *Portrait of an Artist*, 60.

5 It is precisely this "nonrepresentational" aspect of her work that makes it so potentially troubling to political authorities. Bruguera's art occupies times and spaces that are synonymous with achieving real things, not representations of things.

6 On such questions, see Michael J. Sandel, *What Money Can't Buy: The Moral Limits of Markets* (New York: Farrar, Straus and Giroux, 2012), and Eugene McCarraher, *The Enchantments of Mammon: How Capitalism Became the Religion of Modernity* (Cambridge, MA and London: Harvard University Press, 2019).

confronted would-be critics of capitalism, such as Bruguera, with a confusing social universe in which all entities, from the atomized individual worker up to the corporation's upper management, are encouraged to constantly affirm their need to be criticized and problematized.[7] And what makes this variety of neoliberalism even more confounding for its would-be critics and adversaries is that it does not propose specific goals or plans for society so much as it produces an environment rife with constant atelic transformations, a roiling sea of good and bad outcomes that never grows becalmed.

For many progressive, politicized artists, the appearance of this social world has led to a wide-ranging sense of impasse: what to do when the language of "critique" and "critical thinking" has become the definitive idiom for productive management of self and others? In her 2009 performance *Generic Capitalism*, Bruguera tackled such questions directly. In this case a roomful of spectators believed themselves to be about to witness a public forum with the 1960s Weather Underground activists Bernardine Dohrn and Bill Ayers. Unexpectedly, while Dohrn and Ayers spoke, aggressive, ultra-left-wing activists began interrupting them, badgering them with loud, insistent questions. The onetime radicals were accused of losing their edge, and the audience found themselves shocked to see an actual debate of progressive ideas breaking out at what everyone had expected to be an ideological love fest. Only later did the audience realize that the aggressive questioners had been planted by Bruguera. As art historian David Joselit writes, "What had felt like a spontaneous and explosive conversation had therefore been manipulated, which led to another, unmanipulated, but equally impassioned discussion at the symposium the next day where several participants expressed their feelings of betrayal that the discussion had been fixed."[8]

7 Andre Spicer, "The Flaw in Amazon's Management Fad," the *Guardian*, August 17, 2015. https://www.theguardian.com/commentis-free/2015/aug/17/amazon-management-fad-rank-yank-jeff-bezos. For example, the workplace environment at Amazon has been described as involving "constant self-monitoring and self-measurement . . . If you spot any weakness in your own performance, you should be 'vocally self-critical,' explaining your failings to others."

8 David Joselit, *After Art* (Princeton: Princeton University Press, 2012), 63.

This artwork looked and felt very un-art-like, but not only that: the work also managed not to resemble typical, preaching-to-the-converted leftist political theater. Instead, *Generic Capitalism* seemed to be a travesty both of contemporary art and contemporary politics, a status that, ironically, allowed the work to tackle both art and politics in an "explosive" way. In its construction, Bruguera's work displayed a keen awareness that art has gravitated toward two poles: either it becomes "art" that bounces along heedlessly through commercial galleries and art fairs until it eventually arrives at an art storage facility, or it becomes "art activism" that imagines itself as directly engaged in social struggles with established political power. The problem today with both "art" and "art activism" is that each is too obviously and stolidly just what it purports to be. In this sense, Tania Bruguera's greatest achievement as an artist may be that she has serially disclosed the potentially artful buried within the narrowly political and the potentially political buried within the narrowly artful. This is how she has consistently avoided the production of *Guernica*-lite "political art."

"In my opinion, the best form of documentation is to run into a spectator eight or ten years after the performance and they reminisce and recount their feelings and thoughts after witnessing a particular work. The best documentation is the emotional memory of the viewer." [9]
—Tania Bruguera

Questioner: You have referred to the audience as citizens and not as spectators in your performance. Would you agree with Marcel Duchamp when he said that the audience does half of the work?

Tania Bruguera: I absolutely agree with Marcel Duchamp's statement.

9 "*Para mi la mejor documentación que existe es encontrarme a una persona ocho o diez años después y que me diga: 'Me acuerdo todavía de lo que pensé y lo que sentí después de haber estado en esa obra.' La mejor documentación es la memoria afectiva del espectador.*" "Interview with Tania Bruguera" in *Portrait of an Artist*, 53.

It could be said that a twenty-first-century artwork is a manifestation of social relationships.[10] On one side is the artist who makes the work, or at least supervises its production, and on the other will be those who encourage the work's public appearance. These encouragers can arrive in many guises: museum director, fabricator, curator, gallery employee, publicity writer, blogger, art critic, collector, gallerist, or art viewer. Of course, these days, the "artist" may actually be a group (Chto Delat? Claire Fontaine, Reena Spaulings), and the encouragers may be many or few, and the forms of encouragement may be generous or modest, but the situation remains essentially the same worldwide: an artwork can exist before it becomes a manifestation of this social relationship, but it can exist as art only upon entering the flow[11] (as Boris Groys has succinctly described it).

In the old days, encouragers might have been described as patrons, but today that term would be inadequate, since encouragers often possess less symbolic or real capital than the artist herself, and their activities frequently depart from the historical model of the benevolent cultural power player. The best analogy for understanding art today may be to think of the personnel, apparatus, and infrastructures that surround any public event: whether an academic conference, a TV show, a website, or a musical performance, in order for anything to come into existence today, it requires diverse forms of collective encouragement.

With these observations in mind, it may be most useful not to envision contemporary art so much as a collection of static objects made by individuals (a romantic notion at best, a sales pitch at worst) but rather to interpret art as a constellation of events that leave in their wake various indices of their appearance. Such indices can vary tremendously in scope and size. They might consist of a $40 million steel sculpture or a fleeting rumor that some activity once took place

10 This conceptual terrain has been most convincingly articulated in Michael Baxandall's classic text *Painting and Experience in Fifteenth-Century Italy: A Primer in the Social History of Pictorial Style*, 2nd ed. (Oxford: Oxford University Press, 1988).

11 See the description of the churning movement of images and opinions in Boris Groys, *In the Flow* (London: Verso, 2016).

somewhere. The key point here is that no artwork appears today as art without an atmosphere of encouragement surrounding it. Some modes of encouragement may be material/technical (space, lighting), and others immaterial/discursive (word of mouth, professional publicity), but, taken together, encouragers represent an active, creative force that converts work to art.

Tania Bruguera often refers to her activities as a species of *Arte de Conducta* ("Behavior Art"). What she means by this is that her art "works with the reaction and behavior created in those who witness the work and participate in it."[12] This is an art "in which the work becomes complete through the reaction of the audience—their behavior generates new content and meaning."[13] As a result, Bruguera has asserted the relationship between artist and encourager as one of her principal artistic raw materials, and one of her most consistent ambitions has been to transform uninvolved, passive spectators into encouragers, while turning the artist herself into a spectator. Bruguera's pieces rarely present themselves as completed gestures. Instead, they end up proposing a kind of *social sketching* destined to be elaborated over time.[14] Thus, it is impossible to say that these works are ever "completed," because—as Bruguera's understanding of "documentation" makes clear—her works do not "end" in any conventional sense. They are calibrated to resonate, and continue resonating, whether harmoniously or dissonantly, in varied iterations over time. One cannot say, as one might of a painting, sculpture, or even a "conventional" performance, that the work has ever really left the hands of the artist once and for all.

———

12 See Tania Bruguera, "Arte de Conducta," at http://www.taniabruguera. com/cms/609-0-.htm.

13 *Ibid.*

14 Denis Diderot compared sketches favorably with finished paintings, saying, "in the latter the subject is fully worked out for us to look at; in the former, I can imagine so many things which are only suggested." A similar dynamic seems to be the engine in Tania Bruguera's art. One might even imagine her practice as a form of *social sketching*. See excerpt from Denis Diderot, "Oeuvres esthetiques" in *A Documentary History of Art*, ed. Elizabeth Holt (Garden City, NY: Doubleday, 1956), 544.

Of the temporality of her work, Bruguera states, "Just as behavior enters into social life from one generation to another through memory based on experiences, oral tradition or rumors, the documentation of *Arte de Conducta* pieces, although using traditional means of documentation, tries to incorporate collective memory as a form of long-term social permanence and dialogue."[15] In fact, it may be most accurate to say Bruguera's works are intended to exist, first and foremost, as a form of *permanent, active, collective memory*. In the case of *The Francis Effect*, the initial gathering of signatures in front of the Guggenheim Museum only begins a process that conceivably would not end after the minute it took to sign a petition, or the days it might take to gather up signatures, or the months it might take to receive a response from the Papacy, or the years it might take to institute a new Vatican policy regarding refugees—no, more accurately the piece is envisioned as unfolding *without end*, over generations, as the initial art project would fade away and gradually transform into a series of benevolent changes in public policy. In fact, in the ideal version of the piece the artist would eventually become irrelevant as the work definitively left the realm of art to join the larger sphere of life, encouraged ever onward by an increasingly complex infrastructure of care and assistance, and, most paradoxically of all, it would be at the moment when *The Francis Effect* ceased to be art at all that it would become Tania Bruguera's greatest work (of art?).

15 See Tania Bruguera, "Arte de Conducta," at http://www.taniabruguera.com/cms/609-0-.htm.

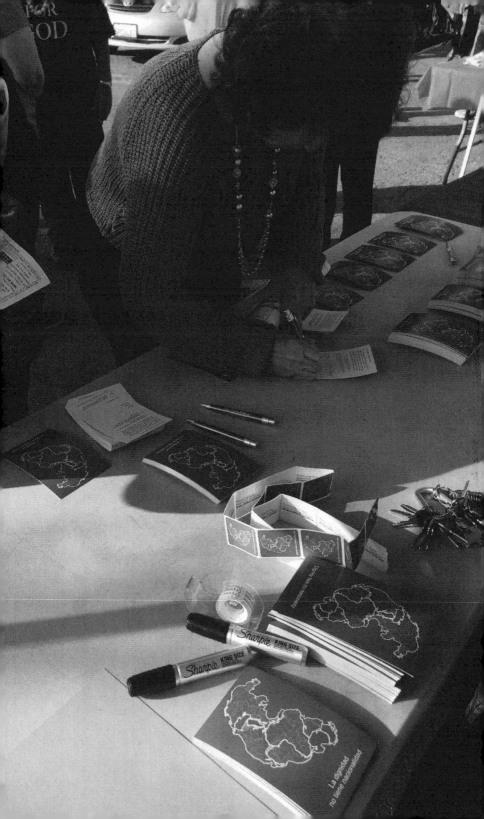

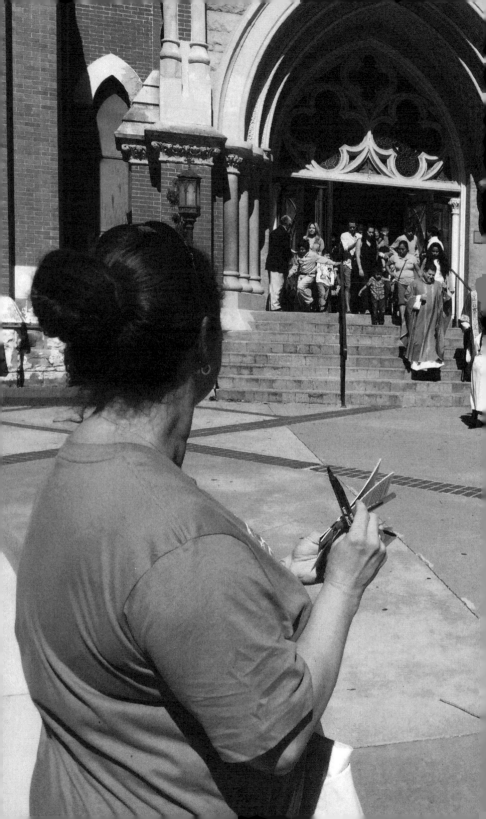

MIGRATION? OR THE SEARCH FOR BARE LIFE

Saskia Sassen

A key assumption organizing my work on migrations is that they happen inside systems. These systems should not be confused with sovereign countries. Rather, they are the transnational space where a given country's military and major economic actors operate.[1] The grandest formats are the empires of an older age: the British, the Dutch, the Spanish empires of our western modernity operated in distinct zones that went well beyond the mother countries but by no means involved the whole planet. Geographies of empire are quite specific, and it is mostly within these geographies that migration flows take place. One way of putting it is that many migrations to the US, for example, started in the Pentagon.

For instance, a whole new migration from the Dominican Republic took off after the US invaded that country in the name of "the Communist threat" because Bosch, a Socialist, had won the election. This was only a few years after Fidel Castro had taken power in nearby Cuba. That invasion built bridges with local Dominicans who were the food sellers, the car fixers, the cleaners, the barbers, and more, serving the needs of the US Army occupiers. The locals who migrated to the US later on did not do so for political reasons. A bridge had been built through the US invasion: "If I can be of use to 'los

1 I first developed this analysis about migration in *The Mobility of Labor and Capital: A Study in International Investment and Labor Flow* (Cambridge: Cambridge University Press 1988).

Americanos' here in my country, I can also in their country." Some Dominicans decided to use that bridge.

And this is a sequence of steps that in one shape or another has been in play in emigrations from diverse countries and areas of the world. Usually, *new* migrations take off when a bridge is built by the country where those migrants went. It need not be military. It is very often one or another type of economic activity.

When we recognize that migrations tend to happen inside systems, we can also understand why poverty as such is not enough to explain migration, and why the estimated total of under three hundred million migrants in the world is relatively small, given the almost three billion poor in the world. Communities that have long been poor may not have emigrations. Or, if they do, it can be shown that they start at some point—even when a household or a community has long been poor. Most major migrations of the last two centuries, and often even earlier, can be shown to have beginnings; they are not simply there from the start. It also explains why we do not have far more migrations—especially in earlier periods when it was easier to enter another country.

Evicted By Development: A New Type Of Migrant?

Thirty years of international "economic development" policies have also contributed major negative conditions in many of the less developed regions of the world. Massive mining, land grabs, water grabs, and plantation agriculture have expelled whole communities from their habitats. Moving to the slums of large cities has increasingly become the last option for those expelled from their land and villages. At least some of the localized wars and conflicts arise from these destructions, in a sort of fight for habitat. And climate change further reduces livable ground.[2]

2 These are all issues I develop at length in *Expulsions: Brutality and Complexity in the Global Economy* (Cambridge: Harvard University Press, 2014).

Today we see the rise of the migrant evicted from her small farm or shop by these kinds of large economic development projects. Elsewhere I have argued that this is a migrant subject for whom we lack a designation. The core feature marking these migrants is that they are the victims, directly or indirectly, of a mode of economic development centered on extractions—of land, metals, water, and more. They are, thus, refugees who have been expelled from their land by modes of development that are measured as positive economic growth.[3]

The cases I focus on here bring to the fore an additional feature: extreme violence. When this is in play it has the power to obscure other factors that actually feed the violence. Among such factors are land and water scarcity and vast new development projects such as mines and plantations. Persons displaced under these circumstances are de facto refugees who have been expelled from their land by what is measured as positive economic development.[4]

When these migrants appear at our borders, they are not recognized as refugees who have lost their livelihoods, because their countries' standard economic measures show growth in advanced economic sectors. And we lack a category that recognizes that each year millions of small-scale farmers and members of a modest middle class are expelled from their land directly by major firms and major development projects. These refugees of economic development are invisible to the eye of the law.

New migrations are often far smaller than ongoing older migrations. But catching them at the beginning offers a window into larger dynamics that catapult people into migrating. Emergent migrations have long been of interest to me: this is the migrant as indicator of a history in the making. In contrast, once a flow is marked by chain migration, it takes far less to explain that flow. My focus is mostly on that larger context within which a new flow takes off.

3 I develop this idea extensively in "A Massive Loss of Habitat: New Drivers for Migration," *Sociology of Development (2016), 2(2):204–33.*

4 *Ibid.*

Here I focus on two extreme flows that exemplify a particular set of new migrations that emerged over the last decade. One of these is the sharp increase since 2014 of migration to the US by unaccompanied minors from Central America—specifically Honduras, El Salvador, and Guatemala. The second is the surge of seven hundred thousand Rohingyas, expelled from Myanmar under brutal persecution, in just three months in late 2017. Each of these flows is easily seen as part of older ongoing flows. The Rohingya, for example, are a Muslim minority that has long faced religious intolerance alongside the mostly Buddhist population of Myanmar's Rakhine State. They have experienced multiple expulsions, but never quite at the scale of the current one. My focus is on specific factors in each of these new flows that lead me to argue that something is in play that is not usually recognized.

These two examples represent two very different types of flows. Yet each points to a larger context marked mostly by extreme conditions. Further, these conditions can be made visible in ways unavailable to typical migrations, where households often play the crucial role in assigning one or another family member to the migration stream. The flows under examination here emanate from situations larger than the internal logics of households. They emerge from sharply delineated conditions operating at the city level, at the regional level, and at a global geopolitical level. Extreme violence is one key condition explaining these migrations. But violence does not fall from the sky ready-made.

Extreme Migrations

While the violence of war and religious persecution plays a significant role in the migration of unaccompanied minors from Central America and of members of the Rohingya minority from Myanmar, my question is what else might explain these migrations. Wars and violence often are symptoms of a deeper condition that we must understand if we wish to grasp the root cause of such extreme flows.

A key vector is the massive loss of habitat for a growing number of what are often minoritized and persecuted peoples. The two refuge-seeking

migration flows I focus on fit in this framing. Also central to my analysis is a concern about specific misrepresentations in the general discussion about each of these two flows. These are evident in the exclusive emphasis on religion in the case of the Rohingya and on urban violence in the case of Central America's minors. Such factors are in play, but they, too, have deeper causes behind them that need to be recognized. This is especially important because these deeper causes are obscured by overwhelming, though unwarranted, certainty regarding the standard explanations—in both the general debate and in more specific research.

I will start by looking at Central America.

When Minors Go Solo: Central America

Central America is one of the key regions where the flight of unaccompanied minors rose sharply a few years ago. "Urban violence" has become the leading explanation among those studying this escape of minors from cities and their decision to try getting to the US, which means crossing the whole of Mexico.

Yet there is more to the picture. In my reading, we need to trace this violence back to the destruction of smallholder rural economies. Smallholders are small-scale agricultural operations, usually run by a family on a small plot of land for subsistence farming. This is one essential overlooked factor at the origin of disastrous outcomes. Powerful families with vast property holdings know how to extract wealth from land. They are key actors in pushing out smallholders to develop large-scale commercial plantations, mines, water projects, and more. Private armies help expel the smallholders and threaten or even kill activists fighting for the rights of the smallholders. Some small landholders die at the hands of the private armies. Others escape to lands of lower quality and little interest to the big landowners.

Cities, increasingly, are the only option for those expelled from their land, and many such families have eventually wound up in the cities of Central America. But the cities lack jobs and options for displaced rural families. The drug trade is one of the few easily accessible

economies here, and it has often been the only one available to displaced smallholders. One outcome is that many displaced rural workers have been killed in drug battles in Central America's cities.

Out of this disastrous mix of conditions comes the desperate hope of getting to the US. While Central America has long been an emigration region, for both political and economic reasons, the flow of unaccompanied children is new. They are driven by extreme fear of the urban violence that has left growing numbers of minors on their own, without caregivers.

US Customs and Border Protection data show that a first major flow of about sixty-three thousand unaccompanied minors, mostly from Central America, crossed the southern US border between October 1, 2013, and July 31, 2014. This is nearly twice the number of child migrants who came during the same period the previous year. The estimate is that by the end of 2014, up to ninety thousand unaccompanied children had crossed the border into the US. Before 2012, more than 75 percent of unaccompanied children were from Mexico. By 2015, only 28 percent were from Mexico, and the rest from Guatemala, El Salvador, and Honduras.

What we do not know is how many of these minors never made it. We know only the numbers of those who arrived in the US, driven by fear. Being forced off their land by private armies marks the beginning of harsh, high-risk lives in cities rendered violent by the drug trade and the absence of reasonable economies.

The Murderous Expulsion of the Rohingya

The Rohingya, a Muslim minority, have long lived in Rakhine State, one of the poorest and most isolated provinces of Myanmar, on the country's western side. They also have long been persecuted by Myanmar's military.

This persecution took on an unusually extreme violence in 2012, when the country passed new laws that opened up its vast resources

to foreign investors from a growing number of countries. Over a hundred thousand Rohingya were expelled from their villages in a fairly central part of Rakhine State. The villages were burned down and the Rohingya placed in camps, with the promise of a return to their villages. They are still in the camps today, their former villages evidently put to better economic use given their proximity to Sittwe, Rakhine State's main city.

Myanmar has several other minoritized peoples who have also lost their land and resources at the hands of the army, including minoritized Buddhists. Behind these grabs of lands long used and occupied by diverse minoritized peoples are major investors, both national and foreign. They are interested in natural resources: timber, minerals, water.

But the extreme events of late 2017 mark a whole new phase in the scale of evictions of the Rohingya: an estimated one hundred thousand shot or burned to death in their homes, seven hundred thousand escaping to Bangladesh in a few months, over 350 villages burned to the ground. Local peoples and a vast international world of concerned individuals and institutions invoked religious persecution as the only explanation.

At this point I want to emphasize one specific aspect that led me to a new understanding of a critical but overlooked element in this short, brutal history. I can accept the explanation centered on religious persecution—in this case anti-Muslim persecution; this was and remains a major factor. The risk of such a strong and persuasive explanation, however, is that it can easily obscure other factors in play. Yes, some hard-line Buddhists in Myanmar have proclaimed that killing the Rohingya is a necessary act. And yes, the Rohingya evidently never mixed easily with the other inhabitants, and in the current period this persecution has become extreme.

But when the military burns 350 villages, most of them in one month—September 2017—then there is more in play.

I had already researched the massive land grabs and development projects that the military was enabling across the country.[5] These initiatives included the loss of a third of the vast Myanmar forest to the timber industry; a river rerouted to bring its water to China, leaving local rural communities without water; and sprawling mining developments that displaced local peoples, including minoritized Buddhists. My question then became, what is happening in Rakhine State, that long forgotten and marginal part of Myanmar? What does the Myanmar military want to do there? By early 2017 I had information about a huge development underway south of the area where the 350 villages were burned. I found it by researching China's Belt and Road project. I published an article: China had negotiated a contract with the Myanmar government to develop a $5.7 billion port and a large economic zone. The shadow effect of such a large development was a sharp increase in the price and the value of the land occupied by the Rohingya farther north. Most of the response from the international media was no, it is all about religion.

The Displaced

The flows I have described are mostly refugee flows, even if not formally recognized as such by the international system. They are to be distinguished from the migration of the nearly three hundred million regular immigrants in the world today, who are mostly of the modest middle class and, increasingly, are high-level professionals functioning in the global economy. Today's immigrants are not the poorest in their countries of origin, nor are they motivated by the extreme push factors feeding the two flows described here. And these refugees, in turn, are also usually not the poorest in their countries, even if leaving their home countries leaves them without any resources; many have advanced educations and started out with resources. These new refugees are one component of a larger population of

5 Saskia Sassen, "Is Rohingya Persecution Caused by Business Interests Rather Than Religion?" the *Guardian*, January 4, 2017. https://www. theguardian.com/global-development-professionals-network/2017/ jan/04/is-rohingya-persecution-caused-by-business-interests-rather-than-religion.

displaced people whose numbers are around eighty million. They stand out by their sudden surging numbers and by the extreme conditions in the areas where they originate. Extreme violence and extreme destruction of local economies are two key factors explaining this surge. Climate change, too, is likely to have extreme effects in some of these regions due to what we might describe as development malpractice—with disastrous consequences for local economies and societies in the Global South. It all amounts to a massive loss of habitat, and migration will remain one mode of survival.

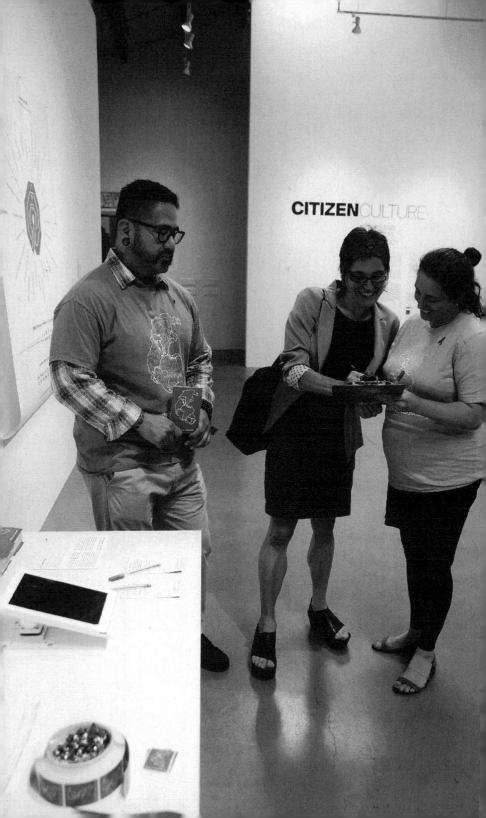

ROME & REFUGEES: PARADOXES OF A CHURCH STATE

Nicholas Terpstra

In 2016, Pope Francis I brought twelve Syrian refugees from the Greek island of Lesbos to Rome, thereby raising hopes, ideas, and questions about how to address one of the modern era's most troubling problems. His gesture also exposed the paradoxes in his own standing as the head of a church and the head of a state. The number of refugees in the world had surpassed fifty million by that point, with few safe or welcoming destinations for those who could move. Francis's moral standing rested on his role as spiritual head of one of the oldest and largest religious bodies on the globe, the Roman Catholic Church. His political standing rested on recognition of Vatican City as a state, though among the youngest, and definitively the smallest, states on the globe. The Vatican is a state without a nation, and it would be fair to say that it exists as much by the indulgence of other states as by their recognition. What can this state and its head do? How do his moral and political standing meet? Is it conceivable that his moral actions might lead other states to question the indulgence of recognition that they grant both the Vatican as a state and the pope as its head?

This is Francis's unique and unavoidable conundrum. Bringing twelve refugees to Rome underscores the shape that conundrum takes in the early twenty-first century. If we look further back we find both the roots of the current shape this problem takes and also some reasons why it is particularly compelling now. What we do not find is answers. The Francis Effect remains to some extent the Francis

Paradox. Our refugee crisis is new only in its details, and the same goes for the pope's conundrum. To explore it is to explore how faith fits necessarily, but only ever with difficulty, into the political order. Refugees have been the victims of that order for at least as long, and faith has been both cause and answer to their situation.

While Vatican City is a relatively new state, it succeeds the Papal State, a territorial entity that a very long series of popes governed as political rulers for over a thousand years. Popes have been balancing the roles of head of church and head of state since at least the eighth century, and the tensions, paradoxes, and conundrums of that balancing act have brought some opportunities and many headaches. They were both the spiritual and also the political leaders of this loose and sometimes fractious collection of cities and territories spanning the central Italian peninsula, and the ambitions of some popes made the Papal State a major political player at key points in the past millennium. Among the founding myths of the Papal State was the claim that it emerged out of the political rubble of the Roman Empire to bring some order and stability into a chaotic international regime. Our modern refugee crisis seems part of the rubble of globalization, and reviewing how a series of popes handled refugees over the past few centuries in particular may help us gain some insight into the paradox Pope Francis inherits, and the effect that he may be able to have.

Rome and Refugees in an Age of Reformation

Today's common definition of refugees comes from the UN High Commission on Refugees in 1951, with a revision in 1967, and identifies refugees as those who: "owing to well-founded fear of being persecuted for reasons of race, religion, nationality, membership of a particular social group or political opinion, are outside the country of their nationality and are unable or, owing to such fear, are unwilling to avail themselves of the protection of that country." Yet the first people to be called "refugees" were a community of Protestant Christians in the late seventeenth century who fled France when their legal privileges were revoked. Known as Huguenots, they were never more than 10 percent of the French population. However, they

represented an identifiable community of Christians who rejected the spiritual authority of the Catholic Church. This put them at odds not only with ecclesiastical authorities in Rome, but also with those many political authorities from the king on down who built their legitimacy on being God's secular representatives of the Catholic Church in France. Tensions between Catholics and Huguenots first arose in the middle of the sixteenth century, pitching France into a vicious civil-religious war that turned both sides into oppressors and refugees depending on the year and the place. When Huguenots seized control of some French towns in the 1560s, they destroyed Catholic shrines and images. When Catholic forces managed a wide-ranging massacre of Huguenots in August 1572, the bells rang in Rome and across Catholic Europe. The Huguenot prince who became France's king in 1594 did so only by converting to Catholicism, creating yet another paradox.

The religious wars that created these first refugees in the late seventeenth century had by that point divided France and wracked Europe for almost two centuries. These were conflicts that Europe's Christians carried out against each other and also against Europe's Jewish and Muslim communities. They were one of the chief reasons why this period saw the emergence of the religious refugee as a mass phenomenon. The religious peace treaties that ended each war allowed Europeans to test new forms of coexistence and in that way to test their own tolerance for difference. Localities and individuals often had an easier time of this than states and churches. Most authorities harbored the dream and policy of uniformity as the thing that would give greatest security to their states and institutions. Yet facts of coexistence on the ground often made it difficult to achieve that uniformity. Necessity was the mother of invention, but its offspring were often orphaned and unwelcome. France saw one of the earliest examples of an effort to grant protected status to a religious minority in the 1598 Edict of Nantes. This was a rare and imaginative internal treaty that recognized the legitimacy of Huguenot marriages and wills and gave the community some walled cities and judges to protect both. It was a practical and political compromise that had few Catholic defenders anywhere, and certainly none in Rome. Yet France also offers an early example of this kind of protected status being eroded steadily to the point of

meaninglessness. The Edict of Nantes was officially revoked within a century, and the result was an exodus of Huguenots seeking refuge outside of France. Protestant rulers in the Netherlands, England, and parts of Germany recognized an obligation and opportunity in these "*refugies*": London and Amsterdam had so-called French Churches, 20 percent of the population of eighteenth-century Berlin was French Huguenot, and some made it to New York, Virginia, and Florida.

Innocent XI was pope when the Edict of Nantes was revoked, and he had no time, patience, or toleration for Huguenots. To be fair, the Roman Curia was not being uniquely narrow-minded. While those late seventeenth-century Protestants who fled France were the first to carry the name "refugee" with them, they were merely the latest victims in a process of religious purification that divided Europe from the late fifteenth century. We know it as the Reformation, and if its positive side meant embracing spiritual values and enacting religious and social reform, its negative side meant marginalizing those of different religious confessions and spiritual orientations, and often expelling those who were thus seen as religiously and socially "deviant." There was no shortage of political expediency and economic opportunity to shape the resulting melee as many thousands of Jewish, Muslim, Catholic, Protestant, and Radical religious refugees moved in trickles or waves around and off the European continent for two centuries and more. Yet at the heart were people. Thousands of Catholics and Protestants fled England as the throne passed from one monarch to the other in the mid sixteenth century. Catholics fled from the Netherlands to Germany and France in the 1560s, and Protestants followed in the 1570s and 1580s. Reaching to the Judeo-Christian Bible to give their flight meaning, priests and pastors on both sides compared themselves to the Israelites fleeing Egypt under Moses, barely escaping with their lives, suffering through a desert without water, food, or hope, and seeking a promised land where they could build a future.

The Exodus story gave some hope and meaning in the sixteenth, seventeenth, and eighteenth centuries. But it brought no food to the table nor change to policy. Early modern Catholic authorities from the local parish priest to the pope in Rome saw their own refugees

as victims of an unholy persecution who deserved protection and charity. At the same time, they saw Protestant, Jewish, and Muslim refugees as adherents to a false religion who deserved a purifying religious discipline. They wrote catechisms that defined the true faith more clearly and narrowly, and they trained and sent missionaries out and around the globe to spread that true faith. They also revivified older institutions like the Holy Office of the Inquisition to ensure that this true faith would be practiced consistently and that deviations would be prosecuted with full judicial rigor. The Inquisition was, above all, an institution born out of a firm commitment to applying proper legal procedure to the challenge of purifying both the Church and the societies over which it assumed spiritual responsibility.

The result is that for many centuries the Catholic Church's main contribution to the refugee crisis was in creating the forms, institutions, and energies that made it worse. It was certainly not alone—all religious confessions proclaimed the same exclusive hold on truth and devoted enormous energies to identifying and protecting themselves from spiritual enemies both real and imagined, both inside and outside their borders. And here was the paradoxical reality that drove the early modern refugee crisis: religion was the language of inclusion and of exclusion, and these languages were tightly woven together. The religious drive for purification was one of the major factors creating refugees. The religious injunction to charity was among the only solutions when refugees fled their homelands and sought shelter across borders and boundaries. Inclusion and exclusion also merged in what Alexandra Walsham has called "charitable hatred"— the conviction that one did no favor to one's enemies by accepting their heresies, if those heresies would send them to hell.[1] Better to firmly correct them in the hope of pushing them into heaven. There were two sides to the coin of true charity: it succored the deserving, and it scourged the deviant.

Reformation movements that challenged Catholic theology and institutions multiplied across Europe in the early to mid sixteenth century,

1 Alexandra Walsham, *Charitable Hatred: Tolerance and Intolerance in England, 1500–1700*, (Manchester: Manchester University Press, 2006).

leaving some in Rome despondent about the prospects for their True Faith. They responded by turning Rome into a refugee center sheltering communities of exiled Catholics from across Europe. Yet they also turned it into a missions center outfitted with a variety of spiritual and diplomatic tools, including new religious orders, new texts and liturgies, new colleges training clergy, and diplomatic and military support for those Catholic rulers working to contain or reverse advances made by Protestants, Muslims, and Jews. There emerged a new determination to promote that True Faith in its exclusive purity, and the resulting recatholicizing campaigns changed the political and religious landscape across Iberia and Eastern Europe in particular. They also created new waves of religious refugees who dispersed south to North Africa, east to Russia, west to North European states, or across the oceans to colonies in the Americas and Asia.

Rome and Refugees in an Age of Nationalism

Religious changes in the Reformation period had first turned the early modern refugee challenge into a mass phenomenon. Yet the largest numbers of refugees were generated not when reforming preachers and missionaries were first active in the fifteenth and early sixteenth centuries but when monarchs and nation states took it upon themselves to act as the promoters and defenders of religious creeds in the centuries that followed. Hundreds and thousands fled in the expulsions during the first phase of the Reformation in the late fifteenth to mid sixteenth centuries. This rose to hundreds *of* thousands by the seventeenth century, and expulsions continued, though at a lower rate, well into the eighteenth century. This is the period of the Enlightenment, a time we often associate with the fading of transcendent religious convictions and confessional differences. Was this another paradox?

Religious convictions didn't fade in the Enlightenment quite so much as they metamorphosed. And at a certain level, it was churches—and the Catholic Church above all—that suffered as a result. The language of being God's Chosen or Favored People did not require a church to endorse it, preachers to proclaim it, or liturgies to exercise it; it was the

creed of every nationalist in Europe. Eighteenth-century governments worried less about religious truth than about security and order, and they expelled or welcomed minorities accordingly. The Archbishop of Salzburg drove the last gasp of Reformation expulsions when he emptied the parishes around the city of twenty thousand Protestants in the 1730s, and the British did the same overseas when they removed 11,500 Catholic Acadians from the Canadian Maritimes in the 1750s, shipping them directly to France or to other parts of its American colonies. Both authorities saw these religious dissenters as "fifth column" enemies and were willing to take a scorched-earth policy to remove them. Rome itself ceased to be a refugee center save for those high-profile exiles like the Stuart kings of England, banished as part of a palace coup in 1688 that saw James II replaced with his daughter Mary and her husband, William of Orange. Busy propagandists turned this into a "Glorious Revolution" that ensconced Protestantism as England's national religion and Catholicism as its most dire existential threat.

The Papal State used its personnel, funds, and powers to advance Catholic interests in these diplomatic tensions, but from the eighteenth into the nineteenth century, it was increasingly an anomaly. Its enemies were no longer either religiously distinct or politically external. Enlightened governments and nationalism posed a bigger threat to the Catholic Church in the late eighteenth century, when the governments of Catholic nations turned on Catholic institutions. Spain, France, Portugal, Austria, and several Italian states closed down and expropriated many monasteries, convents, and the entire Jesuit Order. Long before Napoleon and the French revolutionaries implemented Voltaire's cry to "Écrassez l'infâme" ("Crush the horrid thing"), Catholic governments created refugees out of thousands of their clerical coreligionists by reforms that were less hostile toward belief but equally avaricious toward property. The stakes now were those of national loyalty, and the international anomaly that was the Catholic Church and Papal State was largely powerless to stop former defenders from dispossessing it, picking it bare, and making refugees and exiles of its monks and nuns.

The Papal State had pioneered some of the key innovations in state government, including a diplomatic corps, a trained bureaucracy,

efficient tax collection, and a permanent and professional army and navy. Diplomacy and expropriation brought it to its greatest extent in the mid seventeenth century. But this progressive state was no nation. It fell to French revolutionary armies in the 1790s, with Pope Pius VI dying in exile in 1799, and then to Napoleon in 1808. Europe's other powers restored pope and state in 1815, but the bourgeois revolutions of 1830 and 1848 left it seriously weakened. Pius IX had to flee the city in 1849, but there was neither the will nor the way to bring in a liberal representative government. Austrian and French troops defended the Papal State during the wars around Italian Unification, but even as cities and regions fell away and joined the nascent Italian state in the 1860s, the pope steadfastly refused to concede. The end, when it came, had an almost comic opera quality, as Piedmontese troops used cannons to blow down a section of the 1,600-year-old Aurelian Wall and invade Rome—very likely the last real assault on a walled city in European military history.

The pope was now isolated. He refused to become an Italian subject or citizen, or a refugee. When his own Papal State was simply dissolved into the Italian state, he became a self-imposed prisoner locked away in the Vatican Palace and in the adjoining offices and St. Peter's Basilica. The grounds of that complex became the bounds of the new Papal State—now just over one hundred acres in the center of Rome—in treaties made with the Italian government in 1920 and 1929. The Catholic Church retained significant influence over Italian society and politics and actually gained more influence over the Italian school and health systems than it had held before the Lateran Treaties. Yet the Catholic Papal State was now little more than a shell or fiction.

The Papal State had lasted for well over a millennium, and even in its final years was a fully functioning state with a police force, prisons, and passports. But the twentieth century's wars were the wars of nation states, and in that game a hundred-acre enclave had only amorphous influence. The jury is still out on how Pope Leo XII and the Catholic Church responded to the wars those states generated and the refugees these wars produced—and particularly on its response to the fate of Jews in the Holocaust. Leo XII feared that taking refugees

into Vatican City would compromise its neutrality and hence its safety in a city occupied by Nazi troops. While many Catholics in Rome and beyond sheltered refugees, the pope was unwilling to test the limits of his power, or that of his state, in a time of war.

Rome and Refugees in an Age of Globalism

"Separation of church and state" was a cry emerging from the eighteenth century that resonated through later centuries. It was a founding creed in the United States of America, a revolutionary and often bloody achievement in nations like France and Spain, and a gradually accepted reality in most postwar democracies that once went to war over matters of religious identity. It never made sense in the old Papal State or to the papal monarchs who saw themselves as God's regents over body and soul, land and people. Yet it has been the saving grace of the state we know as Vatican City. Here as elsewhere, it allows the Church to be church and the state to be state. The Church of the Papal State resisted until the 1870s both democracy and some human rights that we now take for granted. The Church of Vatican City from the 1960s opened the windows and doors to dialogue with other faith traditions and to refugees of other faiths and nations. This is the Church of a Latin American pope and of believers who now hail largely from outside Europe and North America. The Catholic Church, of all modern churches, experiences most directly the global refugee crisis at its key sources. How can and should it use that experience and its unique status as a state in order to address this crisis?

There is still a state, but what state is it, and why? It has diplomats, a bank, media, and passports. It has the Swiss Guards. It has citizenship, though at present far fewer than a thousand hold it. Singapore, Monaco, and Liechtenstein demonstrate that small states—city-states—can still truly exist. Yet there remains something distinct and almost fictional about Vatican City: a compromise and invention more than a real state. Is it a hope and a solution? Are there creative possibilities to its very existence as a nonnational state that may have new utility in a refugee crisis whose triggers lie in the economic and political upheavals of globalization? Certainly the Papal State was

innovative in the past, and so all of these options should be considered. At the same time, when we consider its history, do we also see reason for caution and concern?

Over the centuries when it was a state like many others, the Papal State acted as many others did. Accordingly, it was more often than not the cause of refugee movements rather than the solution to them. If Pope Francis I now reclaims for Vatican City some of the tools of statehood in order to address the refugee crisis, he will certainly have a profound effect, both immediately and in the long term, and the full paradox of that state's existence will be exposed. It could be a creative response to the greatest humanitarian crisis now facing us. It is a response that surprises us in its imagination. It may also be a response that holds more surprises than we are capable of imagining.

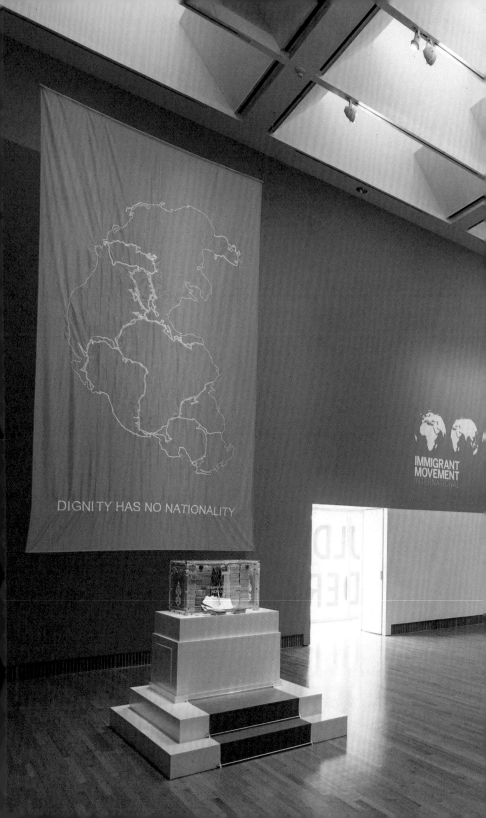

DIGNITY HAS NO NATIONALITY

IMMIGRANT
MOVEMENT
INTERNATIONAL

ABOUT THE CONTRIBUTORS

TANIA BRUGUERA is an artist whose performances question the possibility of political representation while attempting to collapse the distance between art and life and to erode institutionalized injustice. Born in Cuba, she now lives and works in New York and Havana. Bruguera studied at the Instituto Superior de Arte in Havana, then earned an MFA in performance from the School of the Art Institute of Chicago. She is the founder and director of *Arte de Conducta*, the first performance studies program in Latin America, which is hosted by Instituto Superior de Arte in Havana. From 2003 to 2010, she was an assistant professor at the Department of Visual Arts of the University of Chicago. She currently is a senior lecturer in media and performance at Harvard University. Bruguera's work has been featured in Documenta 11, Kassel, Germany, and in the Havana, Venice, Johannesburg, São Paulo, and Shanghai biennials. In March 2011, she began a five-year social project, *Immigrant Movement International*, the first year of which was sponsored by Creative Time and the Queens Museum of Art. Based in Corona, Queens, the ongoing project functions as a think tank for immigrant issues, offering free artistic, educational, and consciousness-raising activities to a community of immigrants. Bruguera is a proponent of *Arte Útil*, a "useful art" designed to address social and political problems.

OUR LITERAL SPEED is a text and art undertaking located in Selma, Alabama, since 2006. They have also been known as Matthew Jesse Jackson, who is chair of the Department of Visual Arts at the

University of Chicago. Jackson is the editor and cotranslator from the Russian of *Ilya Kabakov: On Art* (University of Chicago Press, 2018) and the author of *The Experimental Group: Ilya Kabakov, Moscow Conceptualism, Soviet Avant-Gardes* (University of Chicago Press, 2010; paperback, 2016), winner of the Dedalus Foundation's Robert Motherwell Book Award for outstanding publication in the history and criticism of modernism in the arts. He coauthored and cocurated the book and exhibition *Vision and Communism* (The New Press, 2011), and his writing can be found in *Apollo*, *ARS*, *Afterall*, *Artforum*, *Art Journal*, *ARTMargins*, *Berfrois*, *BlackBook*, *Bookforum*, the *Brooklyn Rail*, *caareviews*, *Critical Inquiry*, *InterReview*, *Journal of Comparative Literature and Aesthetics*, *M/E/A/N/I/N/G*, *Museum International*, *New Left Review*, *October*, *Oxford Art Journal*, *Shifter*, *Slavic Review*, *Slavic and East European Journal*, *Slavonic & East European Review*, and *Third Text*.

LUCÍA SANROMÁN is a curator and writer and director of the Laboratorio Arte Alameda in Mexico City. Previously, she was the director of visual arts at the Yerba Buena Center for the Arts in San Francisco, California. Her work investigates aesthetics in relation to efficacy in social, participatory, and process-based art practice, focusing on the correlation between art history and theory with disciplines outside of the arts. Sanromán was awarded the 2012 Warhol Foundation Curatorial Fellowship and a 2013 Warhol Exhibition Grant for *Citizen Culture: Art and Architecture Shape Policy* at the Santa Monica Museum of Art in 2014. She was cocurator with Candice Hopkins, Janet Dees, and Irene Hofmann of SITE Santa Fe's signature biennial SITElines.2014: *Unsettled Landscapes*. Sanromán is the recipient of a Pew Center for Arts & Heritage Grant for a City of Philadelphia Mural Arts Program project, *Playgrounds of Useful Knowledge*, curated by Cohabitation Strategies.

SASKIA SASSEN is Robert S. Lynd Professor of Sociology and cochairs the Committee on Global Thought at Columbia University. She is a member of the Council on Foreign Relations and the National Academy of Sciences Panel on Cities. Her publications include *Territory Authority Rights: From Medieval to Global Assemblages* (Princeton University Press, 2008), *A Sociology of Globalization* (W.W. Norton,

2007), and *Cities in a World Economy* (Sage, 2011). Sassen has written for *Clarín*, the *Financial Times*, the *Guardian*, the *International Herald Tribune, Le Monde Diplomatique*, the *New York Times, Newsweek International*, and *Vanguardia*.

NOAH SIMBLIST works as a curator, writer, and artist with a focus on art and politics, specifically the ways in which contemporary artists address history. He has contributed to *Art in America, Modern Painters, Terremoto*, and other publications. He has published interviews with Kader Attia, Khaled Hourani, A. L. Steiner and A. K. Burns, Omer Fast, Jill Magid, Walead Beshty, Yoshua Okon, and Nicolaus Schafhausen. His curatorial projects include *Aissa Deebi: Exile is Hard Work* at Birzeit University Museum (2017), *False Flags* with Pelican Bomb in New Orleans (2016), *Emergency Measures* at the Power Station (2015), *Tamy Ben Tor* at Testsite (2012), *Out of Place* at Lora Reynolds Gallery (2011), *Queer State(s)* at the Visual Arts Center in Austin (2011), and *Yuri's Office* by Eve Sussman and the Rufus Corporation at Fort Worth Contemporary Arts (2010). He was also on the curatorial team for the 2013 Texas Biennial. In 2016, he was cocurator and coproducer of *New Cities Future Ruins*, a Dallas convening that invited artists, designers, and thinkers to reimagine and engage the extreme urbanism of America's western Sun Belt. His most recent project was *Commonwealth*, a multiyear undertaking exploring the notion of the commons at the Institute for Contemporary Art at Virginia Commonwealth University, in partnership with the Philadelphia Contemporary and Beta Local in San Juan, Puerto Rico. He is also an associate professor of art at Virginia Commonwealth University.

NICHOLAS TERPSTRA is a professor of history at the University of Toronto. He works at the intersections of religion, politics, and charity in Renaissance and early modern Italy, with a focus on the institutional forms of civil society. This research deals in particular with people on the margins or underside of society (orphans, abandoned children, widows, criminals, exiles, etc.), and looks at how they negotiated their situations in urban society and how those urban societies aimed to deal with them. Recent books include *Religious Refugees in the Early Modern World: An Alternative History of the Reformation* (2015);

Cultures of Charity: Women, Politics and the Reform of Poor Relief in Renaissance Italy (2013), which won awards from the Renaissance Society of America and the American Historical Association; *Lost Girls: Sex and Death in Renaissance Florence* (2010), which has been translated into Italian and Korean; and *Abandoned Children of the Italian Renaissance: Orphan Care in Florence and Bologna* (2005). He has turned more recently to cross-cultural exchanges and the theme of global reformations. This work began with a 2017 international conference, "Global Reformations: Transforming Early Modern Religions, Societies and Cultures," and has taken shape through an essay collection with Routledge (2019), a reader of primary sources called *Global Reformations Sourcebook: Convergence, Conversions and Conflict in Early Modern Religious Encounters* (Routledge, 2021), and a second essay collection, *Reframing Reformation: Understanding Religious Difference in Early Modern Europe* (2020).

CHRISTINA YANG is chief curator at the Berkeley Art Museum + Pacific Film Archive. Previously, she has held positions at the Williams College Art Museum, Guggenheim Museum, the Kitchen, and the Queens Museum. She specializes in building institutional work/culture and examining cultural difference in the visual arts, along with the care of interdisciplinary projects across emerging forms, including conceptualism, social practice, performance, new media, and experimental dance. She is a PhD candidate in performance studies at NYU's Tisch School of the Arts, where she focuses on spectatorship and the politics of the image. Her essay "How to Do Things with Cameras" was published in *Eikoh Hosoe* (ed. Yasufumi Nakamori) by Mack Books in November 2021. She is a member of the feminist collective *Women & Performance, a journal of feminist theory*, where she served as performance reviews editor from 2018 to 2020.

IMAGE CREDITS

1 Installation view, *Tania Bruguera: Talking to Power / Hablándole al Poder*, Yerba Buena Center for the Arts, San Francisco, 2017. Courtesy Yerba Buena Center for the Arts. Photographs by Charlie Villyard.

3 Pangaea.

4 Tania Bruguera, *The Francis Effect* in conjunction with *Under the Same Sun: Art from Latin America Today*, June 13–October 1, 2014; Solomon R. Guggenheim Museum, New York. Photograph by Enid Alvarez.

6 Tania Bruguera, *The Francis Effect* in conjunction with *Under the Same Sun: Art from Latin America Today*, June 13–October 1, 2014; Solomon R. Guggenheim Museum, New York. Photograph by Enid Alvarez.

9 Tania Bruguera, *The Francis Effect* in Dallas, Texas, October 3–5, 2014. Photograph by Kevin Todora.

10 **Top:** Tania Bruguera, *The Francis Effect* in conjunction with *Under the Same Sun: Art from Latin America Today*, June 13-October 1, 2014; Solomon R. Guggenheim Museum, New York. Photograph by Enid Alvarez. **Bottom:** Tania Bruguera, *The Francis Effect* in Dallas, Texas, October 3–5, 2014. Photograph by Kevin Todora.

17 Tania Bruguera, *The Francis Effect* in conjunction with *Citizen Culture: Artists and Architects Shape Policy*, September 13–December 13, 2014; Santa Monica Museum of Art (now ICA LA), Los Angeles. Photograph by Asuka Hisa.

Dignity has no nationality

La dignidad no tiene nacionalidad

HUMANITA
NOFC

The Francis Effect is a petition asking Pope Francis to grant
Vatican City citizenship to all immigrants around the world,
particularly undocumented immigrants and refugees. We invite
you to join that petition by filling out a postcard and adding it to
the trunk, which will be delivered to Pope Francis. You may also
sign the petition online at dignityhasnonationality.net.

Dignity has no nationality